IMAGES
*of America*

# LAND OF UMPQUA

D0775547

**MYRTLE THE MAMMOTH.** As a Columbian mammoth, Myrtle loves history and makes a great mascot and children's ambassador for the Douglas County Museum of Natural & Cultural History.

**ON THE COVER:** Dressed turkeys are ready for shipment to San Francisco at the J.T. Bridges Warehouse in Oakland, Oregon. In the early 20th century, Oakland was known as the Turkey Capital of the West Coast.

IMAGES
of America

# LAND OF UMPQUA

Douglas County Museum

ARCADIA
PUBLISHING

Copyright © 2011 by Douglas County Museum
ISBN 978-0-7385-7492-9

Published by Arcadia Publishing
Charleston, South Carolina

Printed in the United States of America

Library of Congress Control Number: 2010942157

For all general information, please contact Arcadia Publishing:
Telephone 843-853-2070
Fax 843-853-0044
E-mail sales@arcadiapublishing.com
For customer service and orders:
Toll-Free 1-888-313-2665

Visit us on the Internet at www.arcadiapublishing.com

*This book is dedicated to Jena Mitchell, who has collected, cared for, and exhibited the museum's historic photograph collection expertly for more than 30 years.*

# CONTENTS

# ACKNOWLEDGMENTS

The creation of this book would not have been possible without the tremendous help of the following museum volunteers: Richard McQuillan, Ashley Josifek, Dale Greenley, and Joshua Arce. Museum staff members Karen Bratton and Jena Mitchell are not only responsible for the high quality of *Land of Umpqua* but for providing excellent care of the historic photograph collection for years. Most importantly, we need to thank the people of Douglas County for entrusting to our care their amazing photographs and stories so that we may, in turn, now share them with you. Please note that all the images within this book come from the Douglas County Museum of Natural & Cultural History's historic photograph archives. These along with more than 35,000 other images are available for purchase as prints. Thanks!

—Gardner Chappell
Museums Director

# INTRODUCTION

From the crest of the Cascade Mountain Range at 3,342-foot Mount Thielsen to the crashing Pacific waves at the Oregon Dunes, Douglas County, also known as the "Land of Umpqua," covers more than 5,000 square miles of southwestern Oregon. The county is unique in that its political boundaries mirror those of the Umpqua River watershed.

Home to humans for more than 10,000 years, the resource-rich environment provided for an exceptionally high quality of life for native peoples. While the land provided a wide variety of foodstuffs, it was the vast runs of salmon that formed the center of their diet. Descendants of those first inhabitants still call this land home. They were later joined by explorers like David Douglas, who came here in 1826 and for whom the majestic Douglas fir is named, and fur trappers of the Hudson's Bay Company, whose southernmost outpost, Fort Umpqua, was located and is being reconstructed at present-day Elkton. Religious missionaries and gold prospectors came in turn to save souls and strike it rich, respectively. Their accounts of a bountiful land ripe for settlement spurred on one of the largest migrations in human history along the Oregon and, later, Applegate Trails. Those who came to settle here worked hard to provide for their families and establish the farms, businesses, and communities we enjoy today. The living, while not easy, was good, and the Land of Umpqua was known over the years as a center of salmon, melon, prune, turkey, hops, timber, and now wine production.

From the Rogue River Indian War and the Oregon & California (O&C) Railroad land scandal of the 19th century through the creation of federally managed forests that make up more than 50 percent of the county and the "Timber Wars" of the 20th century, Douglas County has been at the center of controversy and change many times over the past two centuries. Today, the Land of Umpqua is home to diverse-minded people who may differ in many ways but share a common love of the land and an appreciation for what it provides us.

We hope that the more than 200 photographs in this volume will provide you with a glimpse into this area's rich history and encourage you to come see for yourself all that the Land of Umpqua has to offer.

# One

# Cascades to Coast

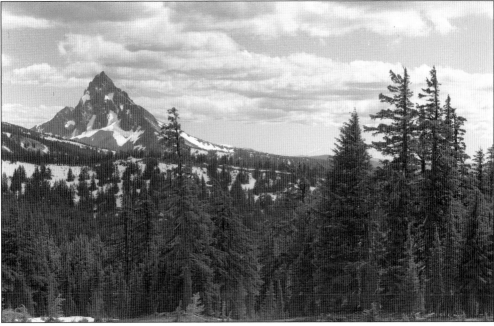

**Mount Thielsen.** Known by Chinook speakers as Hischokwolas, Mount Thielsen, at an elevation of 9,182 feet, is the highest point in Douglas County. Thielsen is an extinct shield volcano in the Oregon High Cascades that stopped erupting 250,000 years ago. Heavily eroded by alpine glaciers, it was named after railroad engineer Hans Thielsen by early explorer Jon Hurlburt and first investigated in 1884 by a team of the US Geological Survey.

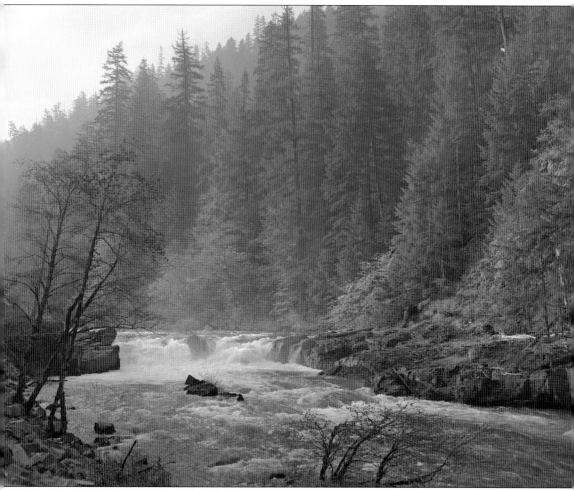

**NORTH UMPQUA RIVER.** The abundant snows and rain showers of the High Cascades fill the North Umpqua River with a turquoise-hued torrent of water. Considered one of America's most pristine rivers, it is renowned for its natural beauty and excellent fish habitat as seen in this photograph from the 1950s.

**DRY CREEK VALLEY.** Also known as the 100 Valleys of the Umpqua, Douglas County is comprised of numerous small creek and river valleys such as Dry Creek. The mountain and hill slopes are covered in evergreen swaths of conifers. Depending on location in the Cascades or Coast Range, the trees may be cedars, pines, hemlocks, firs, spruces, or the most common as well as the state tree of Oregon, the Douglas fir, seen in this photograph.

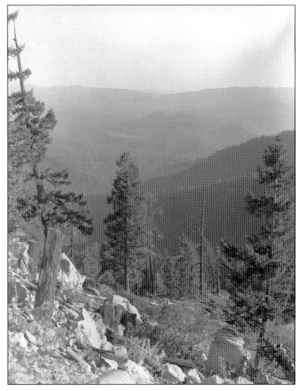

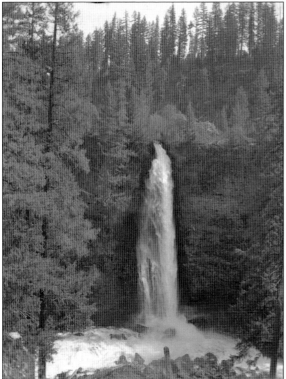

**WATERFALL.** Waterfalls such as this one near the North Umpqua feed cold, clear waters to the river to create a perfect habitat for breeding salmon. Numerous waterfalls are accessible from the Rogue-Umpqua Scenic Byway that follows the river up into the Cascades.

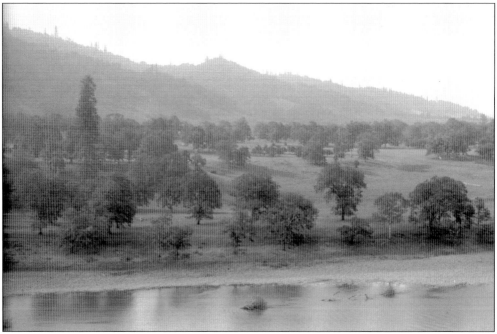

SOUTH UMPQUA RIVER. The slower flowing 95-mile-long South Umpqua River drains the county's southern uplands and courses through the valley bottoms surrounded by oak-dotted savannas and open meadows, as shown in this image from the 1890s. Beginning in the 1820s, trappers and traders of the Hudson's Bay Company began using the river valley to move along Indian footpaths in what became known as the Siskiyou Trail, an important link between the Pacific Northwest and California's Central Valley. Gold was discovered on the South Umpqua River in 1848, causing an influx of gold-miners and rising tensions with native peoples.

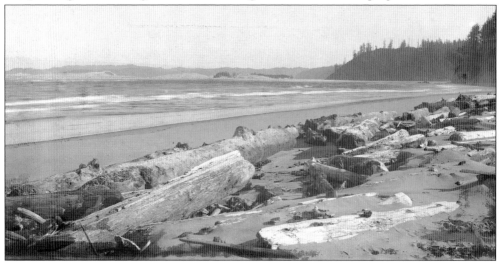

WINCHESTER BAY. The Umpqua River, formed from the merging of the South and North Umpquas, flows into the Pacific Ocean at Winchester Bay. The bay is at the heart of the 27,200-acre Oregon Dunes, the largest expanse of coastal sand dunes in North America, with some towering up to 150 meters above sea level. The dunes are the result of millions of years of storm erosion. Storms also washed up innumerable driftwood logs, as in this photograph from the 1890s.

## *Two*

# MOUNTAIN FORESTS

**TREE-FELLERS.** When logging began, Douglas County's forests echoed first to the sound of axes and crosscut saws. Choppers cut deep notches into which long, iron-tipped hardwood planks or springboards were inserted. A series of such springboards provided a base upon which to stand while the cutting took place and enabled the logger to begin his cut well above the wide portion of the trunk where the tree entered the ground. In this view taken about 1900, Frank Whittaker (left) and Johnny Leach fell a Douglas fir in the Lower Umpqua region.

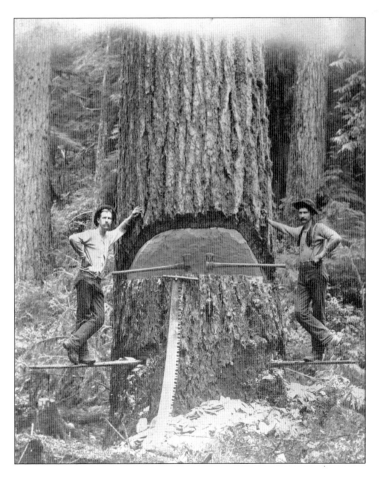

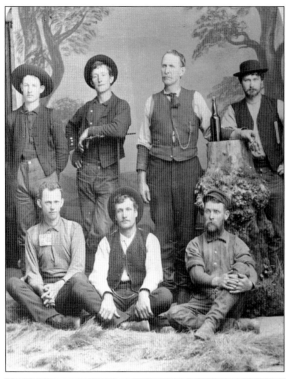

**LOGGERS IN TOWN.** These early-day loggers look to be ready for a night on the town. The man at the far right in the second row is Lincoln Hancock. This crew worked near Gardiner in the 1890s and was photographed in Gardiner. A logger may have worked in the woods for weeks or months before coming to town to spend some of his hard-earned money.

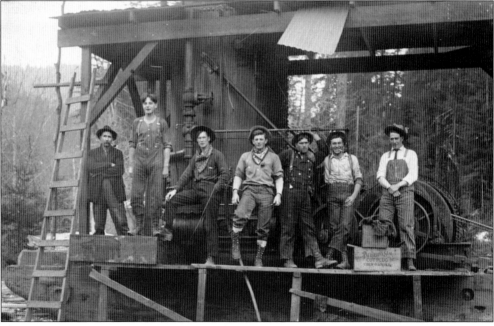

**ROCK CREEK STEAM DONKEY, C. 1914.** In the 1890s, steam engines revolutionized logging. The steam donkey replaced ox teams to get logs out of the woods and accessible for transport to the mills. The donkeys were equipped with large wood-fired boilers. It would take a crew of five or more men to get one log to the landing. They used long cables to pull the logs through the timber on roads made of small logs, called skid roads.

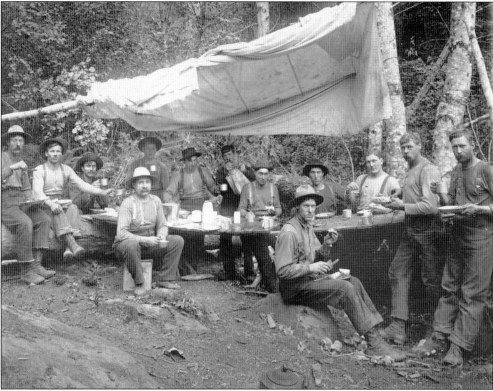

**LOGGER MESS TENT.** This photograph shows what mealtime was like at a logging camp in Douglas County about 1905. These loggers eating at an open-air table were working for the Gardiner Mill Company at Camp Creek in the Lower Umpqua region. Among those pictured, from left to right, are ? Jones, Mr. Guggisburg, unidentified, Alec Esselstrom (crew boss, sitting in front fourth from left), Lin Kirtley, Jess Colby, unidentified, Lon Peasley, Frank Boak, and Bob Kirtley.

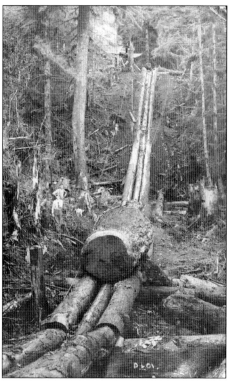

**LOG COMING DOWN CHUTE.** One of the greatest problems in early logging was how to get the logs out of the woods. Skids were constructed of three logs, which were moved and slightly rounded on the ends, and skid roads were greased to help the logs slide down the hillside. A man would steer the logs with a pike pole to keep them from snagging on the way down.

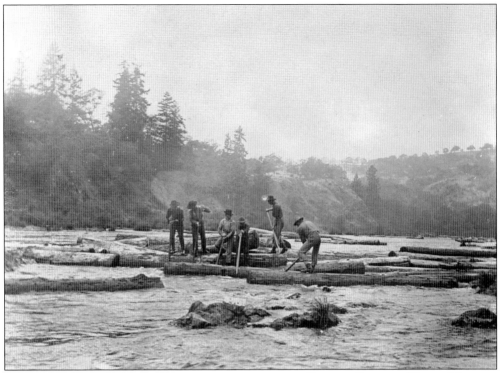

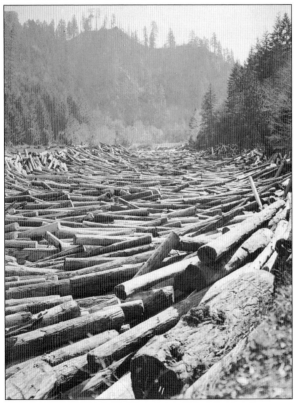

**RAFTING LOGS ON NORTH UMPQUA RIVER, C. 1910.** Loggers rolled logs onto the banks of the river. When high water came late in the fall, the logs floated to a mill where a boom had been built to catch them. Sometimes, the flooding would come too soon and too high and all the logs washed out to sea. When this happened, the loggers lost their summer's work.

**LOGJAM ON MILL CREEK, C. 1905.** Logs that had been transported to the dump sites by train were held until several hundred had been harvested. They were then released and floated downstream to the mill. Oftentimes, the logs would jam, creating hazardous conditions that would have to be broken up. If the logs could not be broken up manually, dynamite would be used to get them moving.

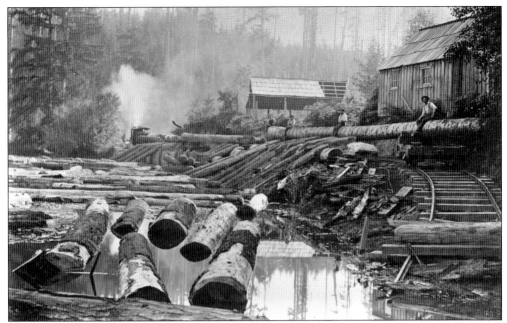

**GARDINER MILL COMPANY LOGGING CAMP, C. 1902.** Logs that had been brought to the landing by steam donkeys were then loaded onto railroad cars and transported to the logging camp, where they could be dumped into the creeks or rivers, then floated downstream to the large mills in Gardiner to be processed, or loaded on steamers and shipped to other ports.

SPLASH DAM ON MILL CREEK, 1905. Splash dams were a marvel of early engineering. When the gates in the dam were closed, water backed up and formed a pond to hold the logs. When the large gates were raised, the water carried them through the dam and down the creek to the Umpqua River and on to the mills in Gardiner.

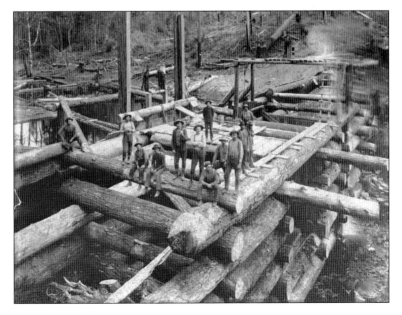

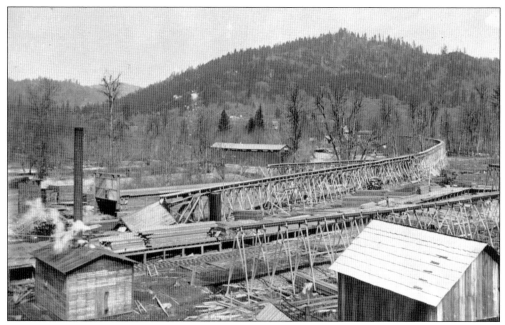

LOG FLUME, COW CREEK, GLENDALE, C. 1905. Loggers in the Cow Creek drainage built monumental log flumes to transport logs for miles, where the terrain was too rugged to build a railroad. The earliest log flumes were built in the mid-19th century and were essentially square chutes of wood raised up above the terrain. These chutes would be filled with water diverted from a river or lake, and logs would be sent down the flume to the mills.

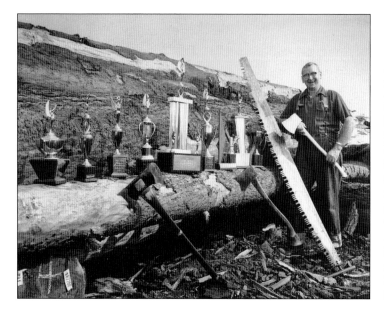

JOHN MILLER. "Big John" Miller, of Sutherlin, competed in many logging championship shows both locally and internationally. His skill in bucking, chopping, and ax throwing were rewarded with dozens of trophies. After moving to Myrtle Creek, he started and ran the Myrtle Creek Logging Competition Show for many years.

**LOGROLLING, C. 1930.** Logs that had been transported to the mills were cold decked (left in large piles for future use) next to the log pond until they could be processed into lumber. "Pond monkeys" used a long pole to roll the logs in the pond at the mill while balancing on another log. This feat became a popular sport at local logging competitions.

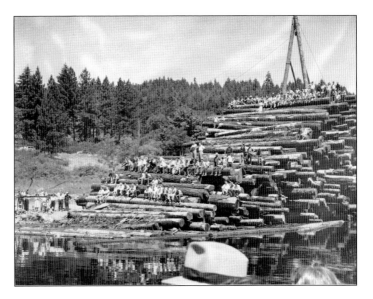

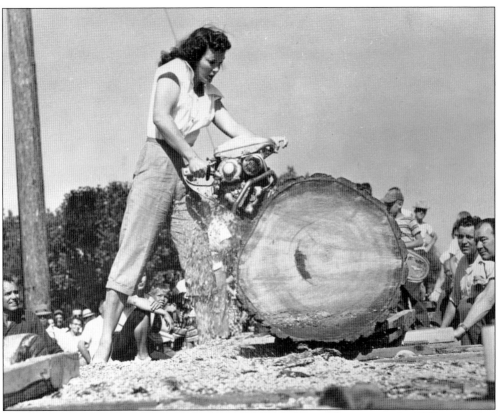

**JERI SMITH, LADY LOGGER.** Not to be outdone by the men, several women in the 1950s competed in various logging activities. Jeri Smith from Camas Valley won first place in the lady loggers contest at the 1953 Timber Days Festival held in Sutherlin.

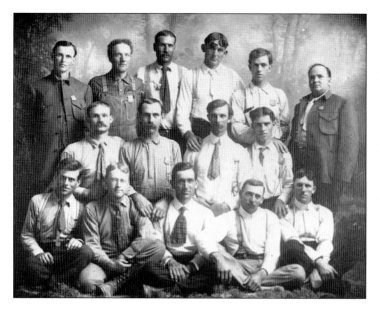

**US FOREST SERVICE CREW, C. 1905.** Vern Harpham (third row, fifth from left) went to work for the US Forest Service (USFS) in 1905. He and fellow crewmen were charged with protecting 1.2 million acres of Umpqua National Forest. They faced the terror of 1910, when much of the northwest burned during an unprecedented drought. The crew continually dealt with fires that ravaged forests.

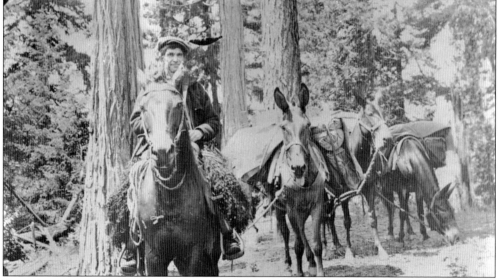

**PACK ANIMALS AT BUSTER BUTTE, C. 1920.** Due to the remote and roadless areas serviced by the Umpqua National Forest Service, pack animals were used to transport supplies to the forest rangers and fire lookout personnel. The man on horseback with a string of mules near Buster Butte on Steamboat Creek is identified as Mallory. USFS ranger Fred Asam named Buster Butte for his faithful packhorse Buster.

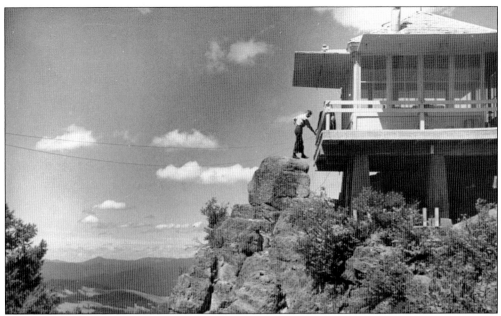

**DIAMOND ROCK LOOKOUT, COW CREEK, C. 1950.** Diamond Rock Lookout was built in 1930 and was decommissioned in 1969. In the past, there were fire lookouts placed on almost every peak or mountain that provided an overlook of the surrounding countryside. The men and women who manned the lookouts had a love of nature. Many were students of forestry. Over time, air surveillance has replaced most of the lookout towers.

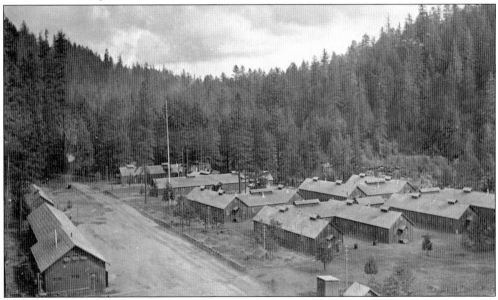

**CAMP SOUTH UMPQUA FALLS, 1934.** The Civilian Conservation Corps (CCC) camp at South Umpqua Falls, east of Tiller, was a typical camp set up to house between 150 and 200 men. The camps consisted of barracks, a mess hall, school complete with library, infirmary, shower facilities, officers' quarters, and electrical plants powered by large diesel generators. The camps provided educational opportunities to any of the men who wanted to participate. The most popular programs were learning to read and write, auto mechanics, and leatherworking.

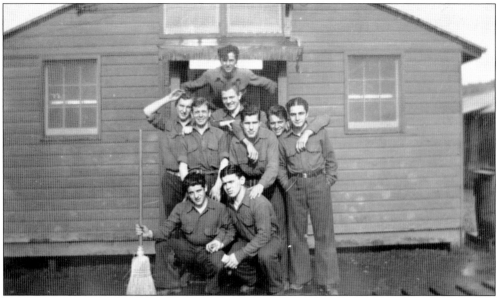

**CCC Camp Elkton, 1939.** The CCC camp in Elkton was located on part of the original Beckley ranch. The primary function of the crews was building roads. They also created parks and campgrounds in the area. After the camp was vacated, it was used during World War II to house conscientious objectors.

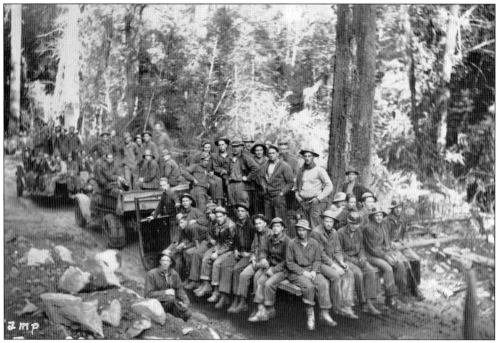

**CCC Camp Tyee, 1933.** A group of young men from Nebraska and Missouri arrived in Roseburg in the summer of 1933. They were surprised to find out the only way to camp was to ferry across the Main Umpqua River. Their main focus was on building roads and bridges in the isolated mountains around the Tyee area. Nationwide, over 1.15 million men took advantage of the benefits offered by the program.

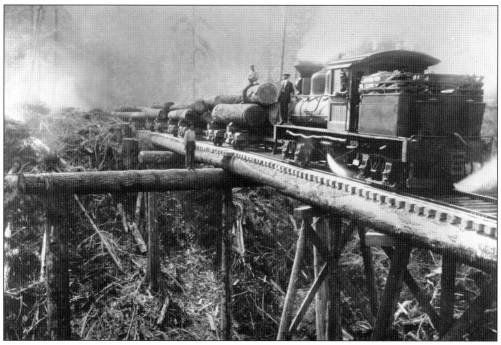

SHAY LOCOMOTIVE. In this photograph taken around the turn of the 20th century, a locomotive crosses a trestle with a load of logs, probably bound for the Gardiner Mill Co. The Shay was a geared engine designed for superior traction and power, a favorite with logging companies in early Douglas County. It was invented by Ephraim Shay, a Michigan logger. It was not unusual for a "lokey" to follow the loads, as most logging railways had steep grades.

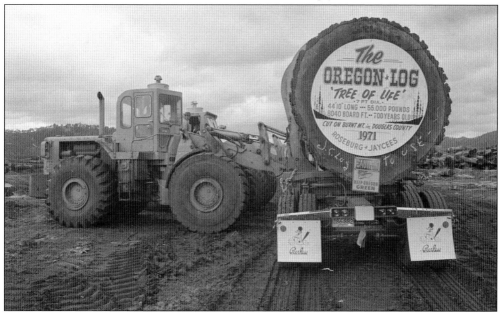

OREGON "TREE OF LIFE," 1971. The Roseburg Chapter of the Oregon Jaycees participated in transporting a "one log load" to various Jaycee groups throughout the state, eventually culminating by taking the log cross-country to the National Jaycee Convention.

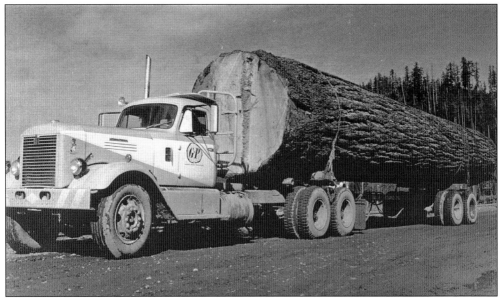

**CENTENNIAL LOG.** In 1959, a 40-foot section of Douglas fir weighing 60 tons was loaded onto a Georgia-Pacific log truck and started on its way to the Centennial Exposition grounds in Portland, Oregon. The log was cut by W.G. "Pokey" Allen, a Camas Valley resident. The tree was originally 9.5 feet in diameter and over 200 feet tall.

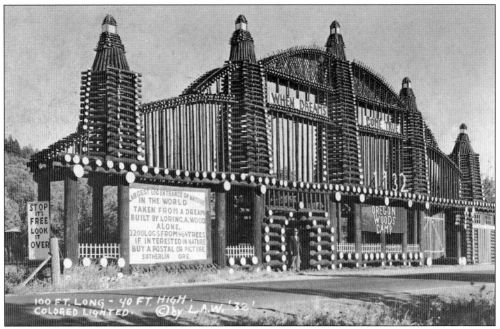

**OREGON WOODS CAMP.** Loring Wood had a dream instructing him to build a beautiful gateway and he proceeded to build Oregon Woods Camp on four acres south of Sutherlin. Seen here in 1932, the structure was comprised of over 3,200 logs of various sizes and was 100 feet long and 40 feet high. At night, it was fully illuminated with colored lights and floodlights. An engineer remarked that "it was one of the greatest pieces of work ever done by a man who knew nothing about engineering."

# *Three*

# RIVER VALLEY
# FARMS AND RANCHES

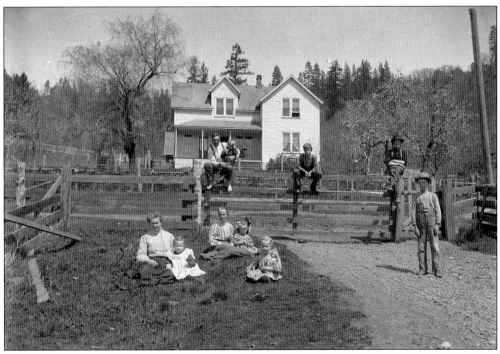

**SETHER FAMILY FARM.** The main draw to Oregon and the Umpqua Valley for most pioneers was the abundant farmland on which they could establish prosperous farms. O.C. Sether and family are pictured in this c.1912 image in front of their comfortable farmhouse. The Sether farm was located on the land of the former New Odessa Colony, a short-lived Jewish commune established in 1882.

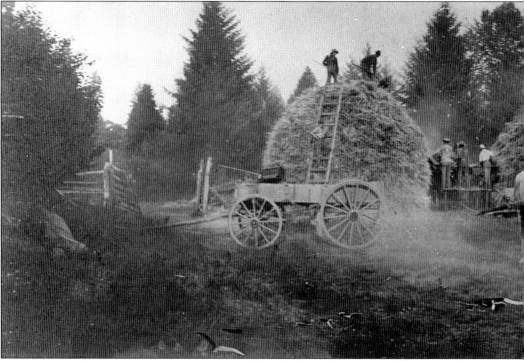

HORSE THRESHING. Before the advent of steam-powered engines and machinery, horses provided much of the energy needed for farm operations. In this early-20th-century photograph, horses are providing the power for threshing on the Blakely ranch in Glide. When steam engines came on

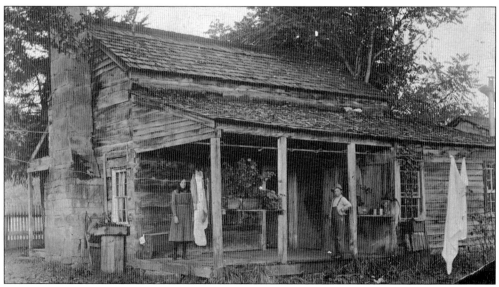

PIONEER FAMILY CABIN. Pictured about 1905, half a century after it was built, the Jonathan Woodruff house was constructed on a Donation Land Claim farm near Cleveland. The family built a much larger two-story house with mill-sawn lumber several years later. Woodruff studied medicine in England and became a physician and surgeon. After the Civil War, he married Lucretia Mae Stearns of Illinois, and they followed Jonathan's uncles who came to Oregon in 1850.

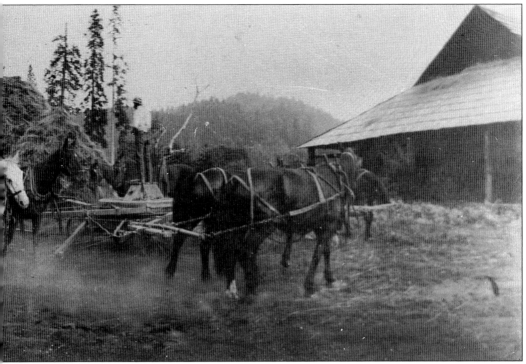

the scene, the amount of power they could provide was measured in horsepower, an amount of energy farmers were already familiar with.

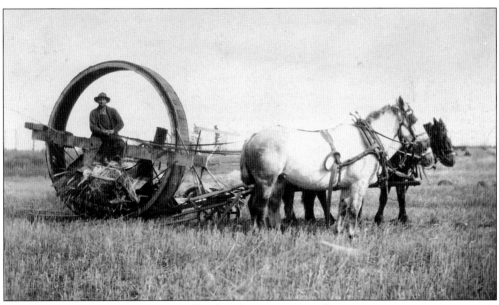

**FERRIS WHEEL BINDER.** The open valley floor became an excellent area to grow grain crops such as in this 1924 photograph of Glen Cox on his 60-acre farm in Garden Valley. The late 19th and early 20th centuries marked an era of constant innovation in farming techniques and technology, as can be seen in Cox's Ferris wheel–type grain binder.

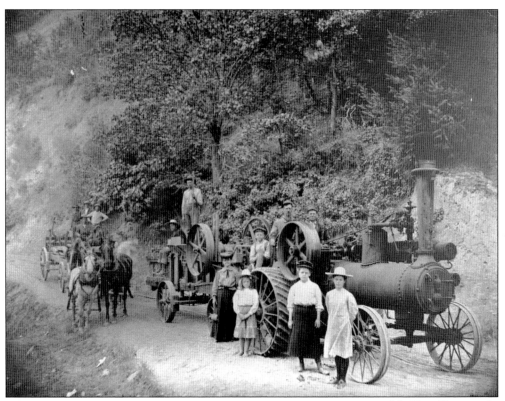

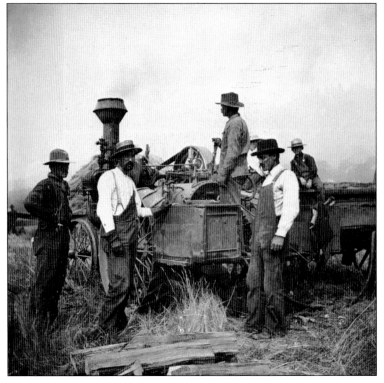

**J.I. Case Engine.** In this c. 1900 image, a J.I. Case steam traction engine pulls a hay baler along a dirt road near the town of Drain. An engine identical to this one as well as a hay baler can be seen at the Douglas County Museum today.

**Traction Engine.** Pictured from left to right, Clarence Cornutt, Ernest Riddle, Alfred Cornutt (on engine), Noah Cornutt, and an unidentified boy use a traction engine on the Abner Riddle ranch.

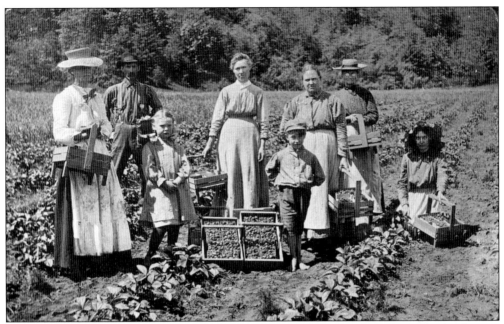

STRAWBERRY PICKING. Sweet red strawberries have been grown every year in the fertile river bottomlands of the Umpqua Valley for more than a century. This particular crop was significant enough to be the center of the annual spring Strawberry Carnival held in Roseburg. These strawberry pickers are in a ripe field near Myrtle Creek around 1910.

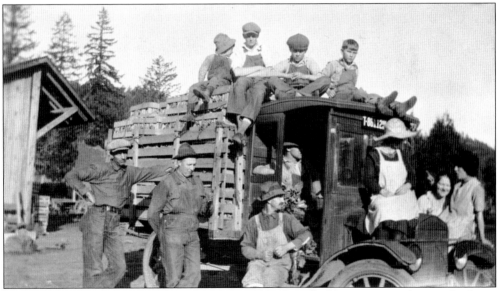

BROCCOLI TRUCK. All sorts of crops were grown commercially by enterprising farmers. In this c. 1920 photograph, a broccoli harvesting crew has just finished loading a truck for market. This may be on the Roy Hatfield broccoli farm on South Deer Creek.

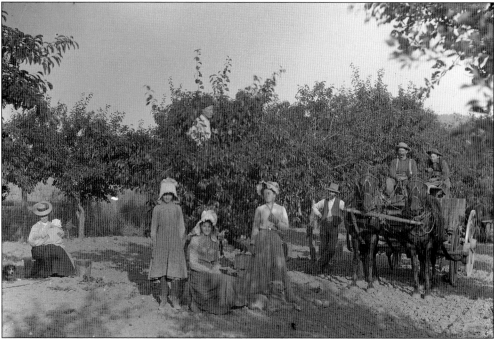

**HARVEST SEASON.** Seasonal crop harvests were a family affair, with every generation pitching in. In this scene from an orchard near Roseburg around 1910, men, women, children and even the family dog pause from their work in the trees.

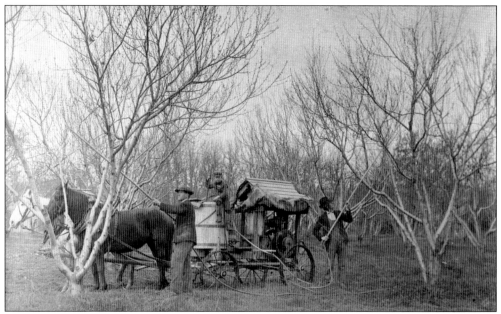

**FRUIT ORCHARD SPRAYING.** Fruit orchards were planted throughout the valley in the 19th and early 20th centuries. An area near Roseburg known as Garden Valley was and continues to be a center of fruit and vegetable production. Pictured is a horse-drawn, power-operated sprayer at work in George Weber's peach orchard around 1900. Floyd Stephens (left) and Bird Branch (right) are doing the spraying, and George's son Earnest is on the wagon stirring the spray.

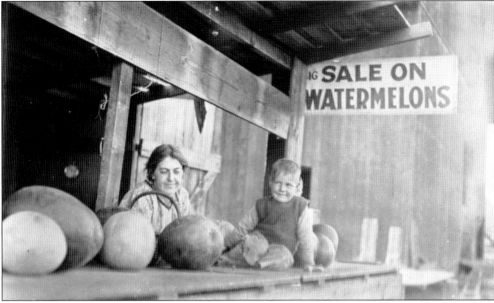

**WATERMELON SALE.** Some of the most historically successful agricultural products of Douglas County were melons, such as watermelon and cantaloupe grown in the Dillard area and celebrated with the annual Melon Festival.

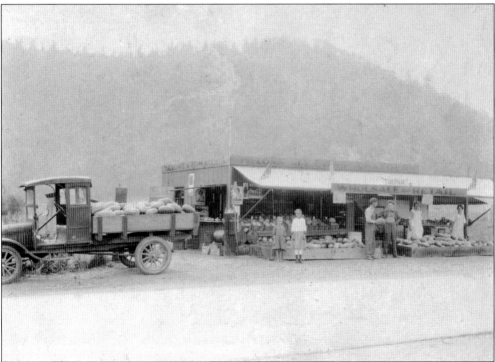

**MELON STAND.** In this photograph from 1915, members of the Evans family pose by a truck filled with watermelons. Few roadside fruit and vegetable stands remain today; Kruse Farms in the Garden Valley area, Burk's in Dillard, and Brosi's Orchards in Winston still do, however. June Evans, the girl to the far left, was killed a few years later when she fell out of a moving automobile.

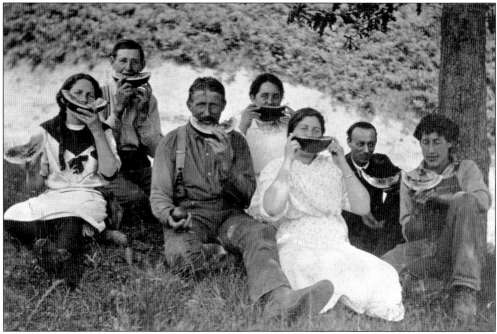

**WATERMELON PICNIC.** This family, the Pyritzes, enjoy late-summer watermelon along the Smith River, a 70-mile tributary merging with the Umpqua at the town of Reedsport.

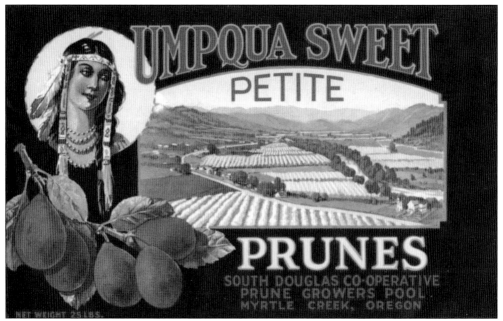

**PRUNE CRATE LABEL.** In this fruit-packing crate label, the artist has rendered a view of the South Umpqua River Valley with spring plum trees in full bloom. The Indian maiden in the left corner is a highly stylized rendering with no local connections.

**PRUNE PICKING CAMP.** Pictured in this 1907 image taken at Missouri Bottoms on Myrtle Creek, are, from left to right, (first row) Donny Lerwill and Walter Rondeau; (second row) Tommy Acusta, George Rondeau, Wallace Rondeau, Rosie Rondeau Lerwill, Emiline Lerwill Young, Clementine Petit Rondeau, Jean Baptiste, Tom Rondeau, Clara Bell Rondeau, Evelyn Rondeau, Francis Rondeau, and Tony Erlebaugh.

**PRUNE HARVEST.** No single farm crop has been more significant locally than prunes. In the era before refrigeration and global fruit shipping, drying provided out-of-season fruit. The industry peaked in the 1920s when this picture was taken of, from left to right, Thelma Cripps (Aiken), Ida Cripps, Henrietta Cripps (Townsend), Frank Root, Irvin Cutsforth, unidentified, unidentified, Doris Cutsforth (Meagher), unidentified, and Bonita Cutsforth.

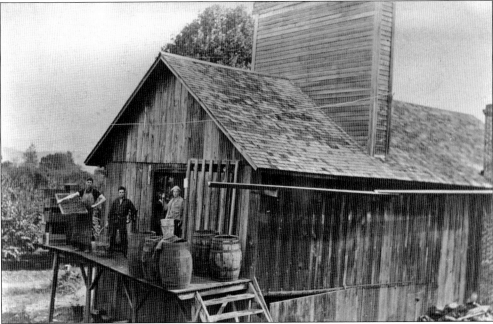

**PRUNE DRYER EXTERIOR.** After the fruit was harvested from the orchards, it was brought to prune-drying barns such as the one in this image from the 1910s. The prune industry took off during this decade with hundreds of acres of plum trees planted between 1910 and 1915. In 1919, prune prices peaked at 22.5¢ a pound. By 1932, over 10,000 acres were in production.

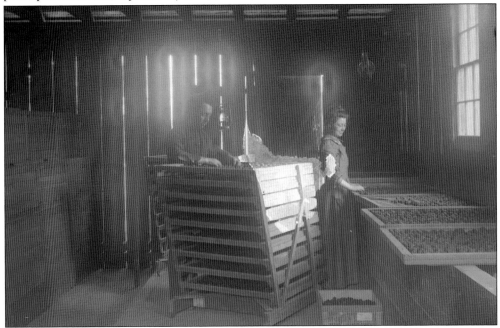

**PRUNE DRYER INTERIOR.** Pitted fruit would be laid out on large screen trays and then placed onto racks to dry. Hot, dry air would quickly desiccate the plums, turning them into prunes ready to ship out across the nation. In this c. 1908 photograph are H.O. Lewis and his wife, Della Brown Lewis, inside a prune dryer with racks of prunes to be dried over 18 to 36 hours.

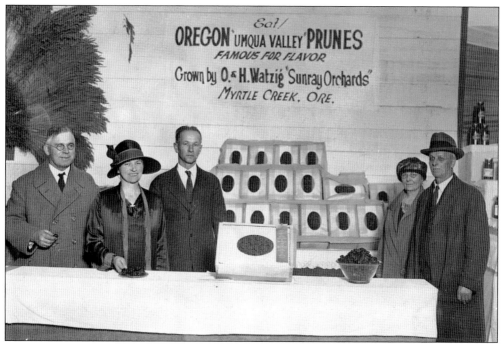

**PRUNE EXHIBITION BOOTH.** Hedwig and Otto Watzig (second and third from left) and Hedwig's parents Anna and Gustof Kasper (on the right) exhibit packaged prunes at the Ninth Annual Manufacturing and Land Products show of the Pacific International Livestock Expo in October 1925 in Portland, Oregon. The Watzig's Sunray Orchards was the last surviving prune producer in the area, lasting until about 2000.

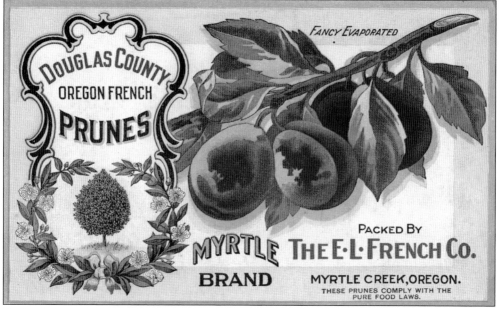

**FANCY PRUNES LABEL.** While prunes today are more often consumed for their health benefits, a century ago, as shown through the marketing efforts of this prune crate label, dried fruit was considered a finer food.

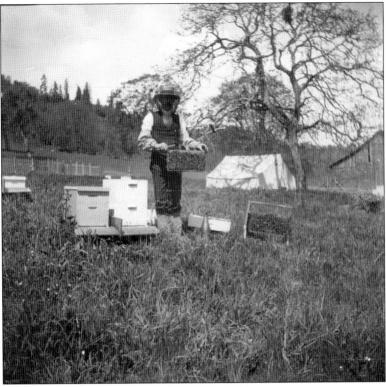

**BEE KEEPING.**
Ernest Riddle is
shown here in the
latest protective
gear around
1900 working
with honeybees.
Having local bees
for pollination
was critical to
the success of the
local agricultural
industry. Hive
boxes like the
ones shown could
be moved from
farm to farm to
pollinate crops at
the optimal times.

**POOR FARM FAMILY.** As
in most 19th century
communities, poor farms
were established in the late
1870s in Douglas County
to care for the destitute,
mainly comprised of widows,
orphans, the elderly, and
infirm. At these county-
supported private farms,
residents held inmate status
and were required to work
under strict conditions in
exchange for basic necessities
and burial upon death.
The Social Security Act
of 1935 led to the ultimate
dissolution of poor farms such
as this one at the Neckter
ranch near Cleveland,
seen here around 1900.

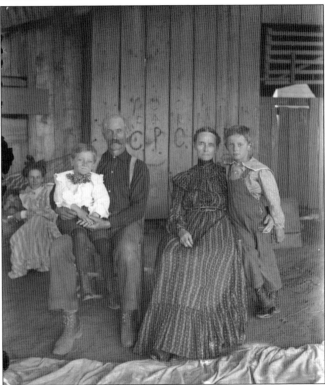

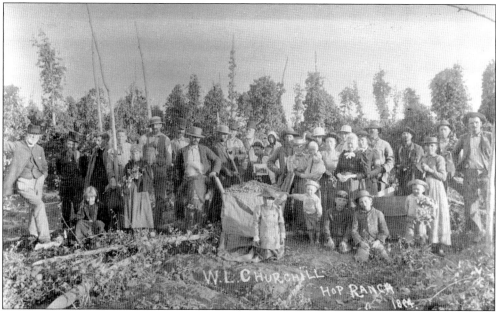

**Hops Ranch Crew.** While vineyards spread across the Umpqua Valley's rolling hills today, hop yards were abundant in the 19th century. Beer was the beverage of choice for many, and the hops needed for its production made for a lucrative cash crop. Umpqua Valley hops were renowned and in high demand, so much so that they were shipped all the way to Europe for beer production in Germany. This multigenerational crew is picking hops at the W.L. Churchill ranch in 1894.

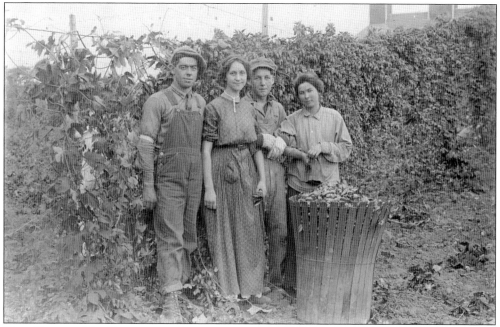

**Hops Pickers.** Hand harvesting of crops was an activity that brought whole communities out to gather produce during often brief periods of time. More than just work, it was an opportunity to socialize with friends and perhaps even do a little flirting, such as among these young men and women at the Stearns' hop yard near Oakland around 1910.

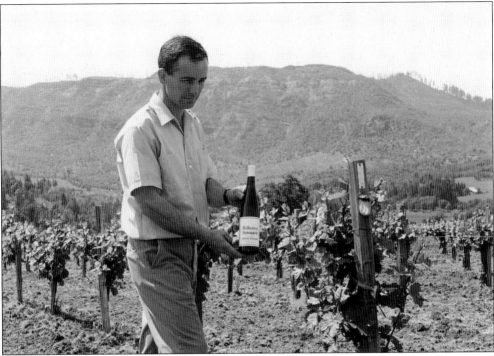

**WINE PIONEER.** Richard Sommer earned a degree in horticulture from the University of California, Davis. He came to the Umpqua Valley in 1961 and started Hillcrest Vineyard. Sommer planted Riesling and small amounts of other grape varieties despite being told by his California peers that it was impossible to successfully grow wine grapes in Oregon. He proved them wrong and today is considered to be a pioneer in the resurgence in grape growing in Oregon.

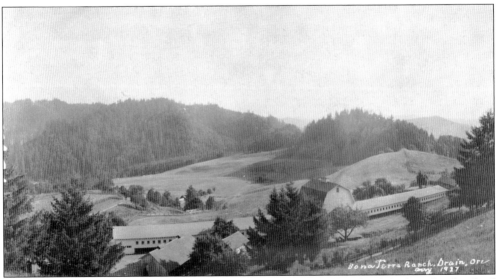

**BONA TERRA RANCH.** Long before Col. Harlan Sanders started selling fried chicken, families fried their own for Sunday dinners. If a family did not raise its own poultry, then places such as the Bona Terra Ranch near Drain were handy local sources to get cooking hens retired from laying duty. This 1927 image of the ranch shows the main barn flanked by two large henhouses.

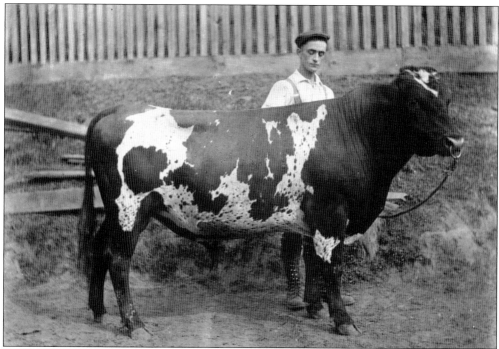

**PRIZED BULL.** Many of the Umpqua Valley's farms and ranches focused on the production of livestock. In this c. 1910 image, a prize Holstein bull is on the Johnson ranch near the coast on the Smith River.

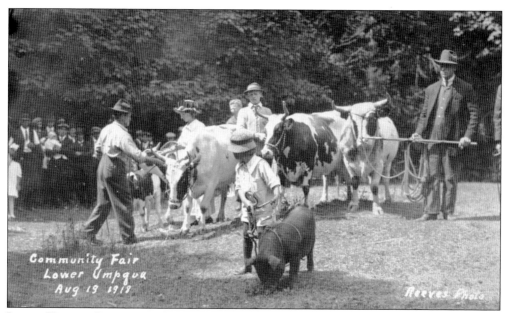

**LOWER UMPQUA COMMUNITY FAIR.** Every year, communities would hold harvest fairs featuring the bounty of locally produced crops and livestock. This photograph, dated August 19, 1918, shows a livestock judging along the Smith River. Ray Dailey is on the far right with his bull.

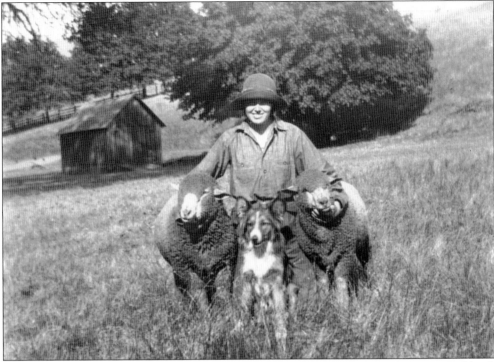

**MILDRED KANIPE AND FRIENDS.** As part of the English Settlement community near Oakland, the Kanipe family established a successful farm. Mildred Kanipe raised sheep and ran a successful small dairy. She was photographed in the 1940s with some of her farm's residents. The Kanipe farm is now a public park where visitors can see the original log cabin and farm buildings. Upon Mildred's death in the 1980s, all of her possessions and family documents were donated to the Douglas County Museum.

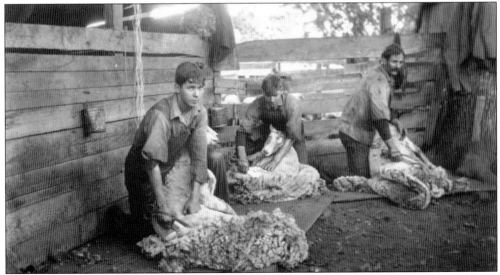

**SHEEP SHEARING.** Every spring, sheep ranchers would bring their livestock in from the fields for shearing, an exhausting chore for both shearer and frightened sheep. In this turn-of-the-century image, the men are using a special type of blade shears to cut the wool from the animals.

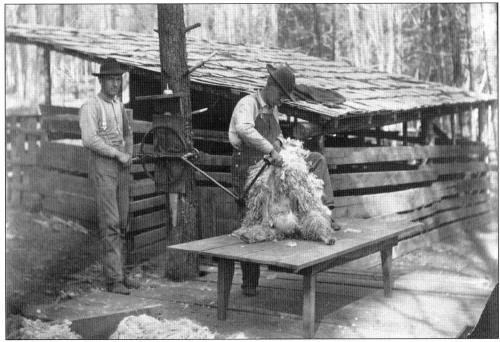

NEW AND IMPROVED SHEEP SHEARING. Just as in anything, shearing technology improved over time. In this 1910 photograph, Frank Cunningham of Glendale is manning a hand-powered sheep shearer. Within a few years, electricity would provide power for the shearing.

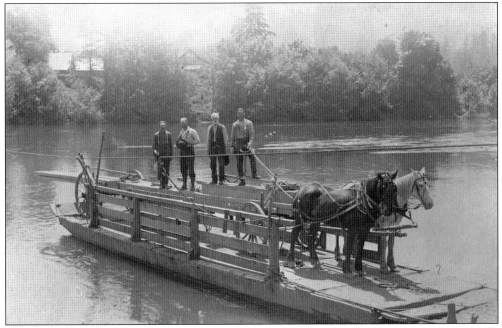

SAWYERS' FERRY. Before bridges were constructed, people were forced to ford waterways with ferries such as this one, made from 40-foot timbers cut at a sawmill located on the south bank of the Umpqua River. In this c. 1919 photograph are, from left to right, Henry Munson, Edwin "Ed" Grubbe, Jake Sawyers, and Alex Sawyers.

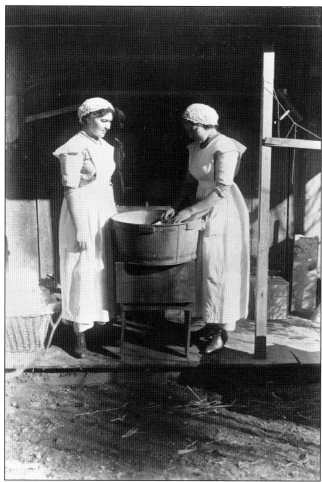

**BLUE MONDAY.** Blue Monday, the popular term for laundry day before the turn of the 20th century, hinted to more than the bluing agent in the rinse water. It also indicated the drudgery in the washing process. Taken in Elkton in about 1910, this photograph of two women involved in this domestic duty provides a graphic illustration of how the task of doing laundry has changed with the passage of time.

**HOMEMADE KRAUT.** In this early-20th-century image, an unidentified young man in a striped shirt with a crock, tamper, and pan of what appears to be shredded cabbage, is making sauerkraut. In the rear are a fine ornamental cast iron stove, tea kettle, coffee pot, coffee mill, and cold-water sink with heads of cabbage and kitchen utensils.

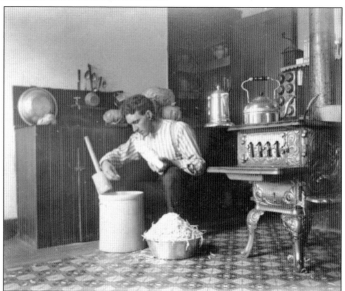

# *Four*

# LOWER UMPQUA AND COAST

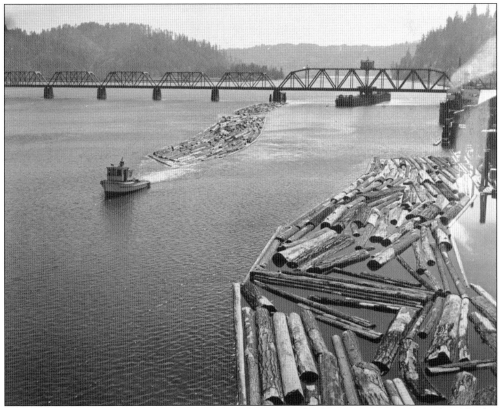

LOG TOWING. Towboat *MAR-SAE* is pulling rafts of logs under the Southern Pacific Railroad bridge at Reedsport on the Umpqua River; the raft is headed downstream. At right is an oceangoing steamship tied up at the Reedsport dock. The view also shows a portion of the Columbia River Packers Association fish plant.

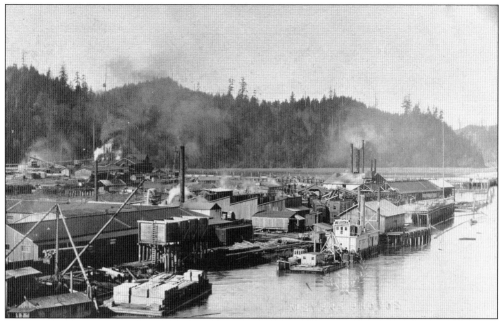

**REEDSPORT WATERFRONT.** Reedsport serves as Douglas County's Pacific port. This picture from the 1920s shows an active waterfront district of mills, canneries, and shipping operations. These industries are all gone now, and the local economic driver has become tourism. The town's location at the heart of the Oregon Dunes National Recreation Area has enabled this to occur.

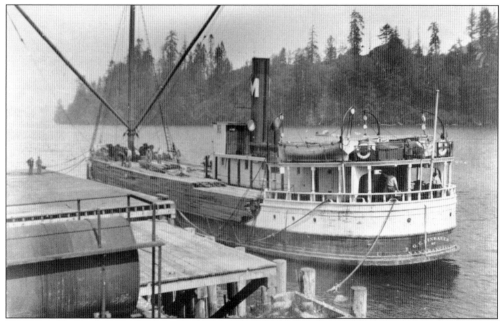

**LUMBER LOAD.** The steam schooner G.C. *Lindauer* from San Francisco is docked at Reedsport with a full shipment of lumber being loaded. Much of the wood needed to reconstruct San Francisco after the 1906 earthquake devastated the city came from Land of Umpqua forests.

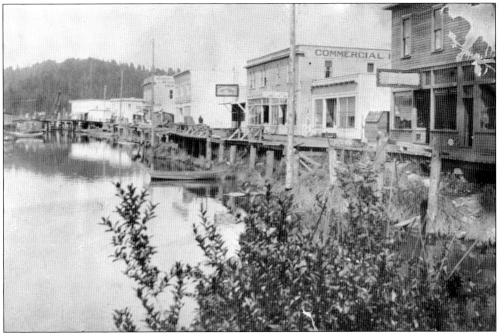

**DOWNTOWN REEDSPORT.** The business district along Rainbow Slough is seen here in the 1920s. Built on marshy ground, Reedsport has struggled with frequent flooding for much of its history. Most of its early buildings were elevated three to eight feet above ground. During the mid-1920s, the marsh on which Reedsport was located was filled by dredging the Umpqua River. The town was named in honor of Alfred W. Reed, a pioneer of the area. Early industries included fish-packing plants and lumber shipping.

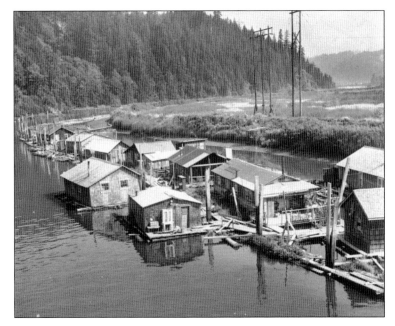

**HOUSEBOATS.** With so little buildable land available, many families found a life on houseboats a sensible option. This picture dates from the 1950s on the Scholfield Creek at Reedsport.

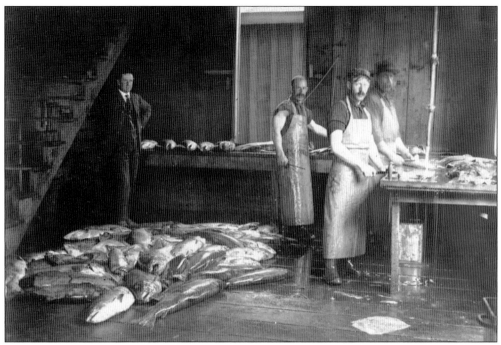

CANNERY SCENE. This 1910 photograph shows three unknown workers cleaning Chinook salmon, with Warren Reed looking on in a Reedsport cannery. The late-19th-century expansion of canning technology enabled the Oregon fishing industry to expand dramatically and allow people all over America to eat Pacific salmon. Today, while canned tuna is still commonly eaten, canned salmon has fallen largely out of favor, and salmon is more often sold whole, fresh or frozen.

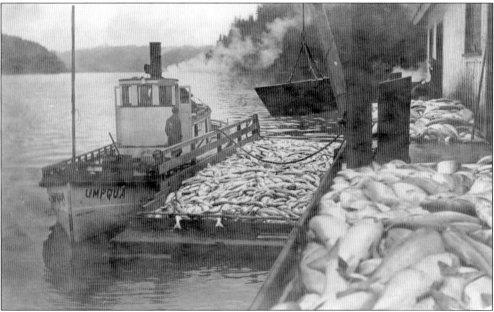

BIG SALMON CATCH. Quantities of salmon that would astonish people today used to be regularly pulled from the Umpqua and nearby Pacific. In this 1912 image, the steam tug *Umpqua* is seen with a barge load of fish at a cannery near Gardiner.

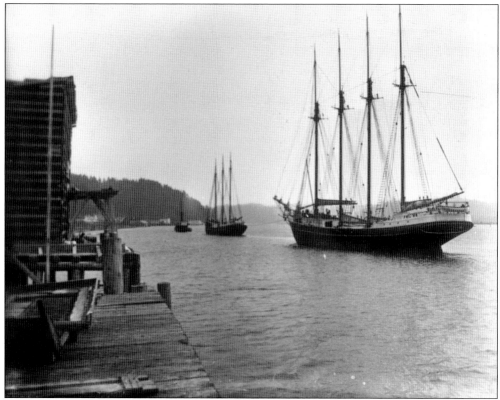

FOLLOW THE LEADER. Tugboats were commonly used to pull the larger schooners to and from the dock. This early-20th-century photograph shows the tug *Gleaner* with both the *Lucy* and the *Caroline* in tow.

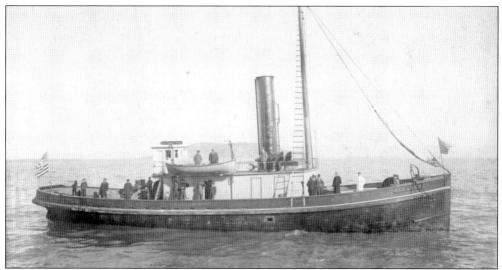

GLEANER TUG, C. 1900. Tugboats played a vital role in early Umpqua River navigation, towing sailing vessels over the treacherous bar at the mouth of the river. Without the tugs, the vessels involved in trade throughout the Umpqua region found the bar crossings exceedingly risky. Several ships were lost while attempting to navigate the bar prior to the tugs being placed into service.

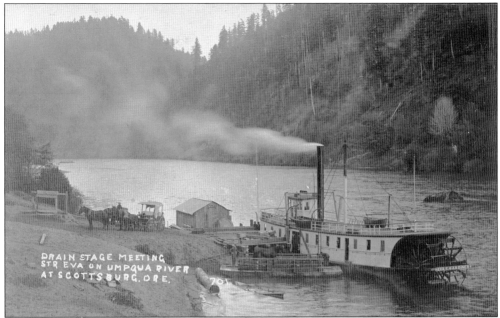

**PADDLE STEAMER.** The steamboat *Eva* is shown in this picture about 1905 at the Scottsburg landing, meeting the stage bound for Drain. This boat was a link for passengers and supplies between Gardiner and Scottsburg. The *Eva* was built in 1894 and plied the waters of the Umpqua River until 1916.

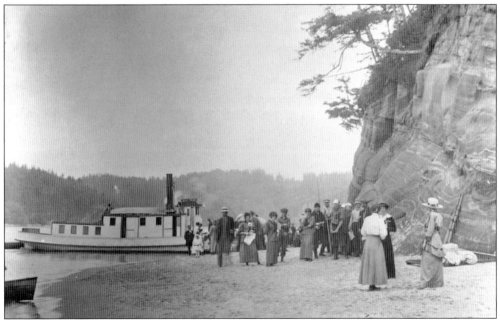

**PROPELLER STEAMER.** A crowd of people is gathered near the propeller steamer *Juno*. Built in 1906 in Marshfield (now known as Coos Bay), *Juno* was part of the "mosquito fleet," an assembly of inland steamboats that operated along Oregon's coast. Coos Bay and the Coquille River were the last areas to convey passengers, with boats operating up until the 1930s. Near Bandon, a few steamers can still be seen in the same place where they were beached decades ago.

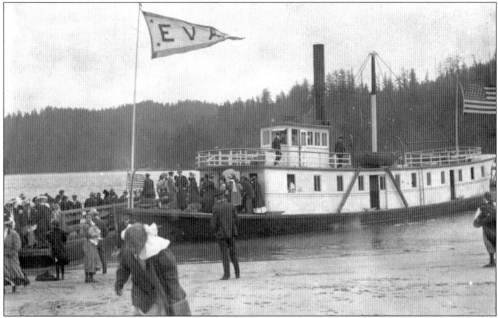

EVA PASSENGERS. *Eva*, with a large group of people debarking, is probably at Fort Umpqua around 1910. The few remaining fragments of the *Eva* as well as a scale model of the ship can be seen at the Umpqua River Lighthouse Museum overlooking Winchester Bay.

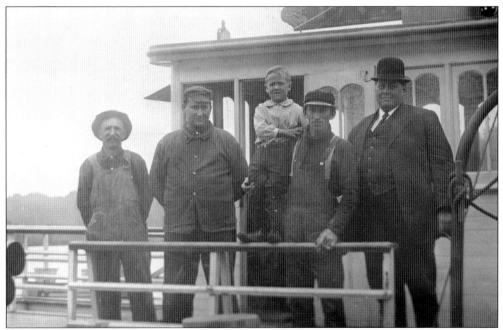

EVA CREW. The crew of the *Eva* poses at the pilothouse about 1910. Pictured, from left to right, are Capt. Jim Graham, engineer Frank Sagaberd, Jim Graham Jr., George Graham, and "One-arm" Olson, an insurance agent.

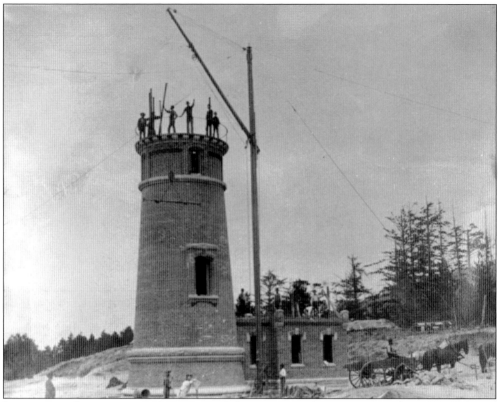

**LIGHTHOUSE CONSTRUCTION.** Umpqua Lighthouse was under construction between 1890 and 1893. This view shows the lighthouse tower and a sheer-leg crane used for hoisting brick used in building the structure. A horse team and wagon and contractor's employees are seen in the photograph. Less than four years after completion of the first lighthouse, a "spring freshet" (flood) undermined the foundation and the 64-foot lighthouse toppled into the Umpqua estuary.

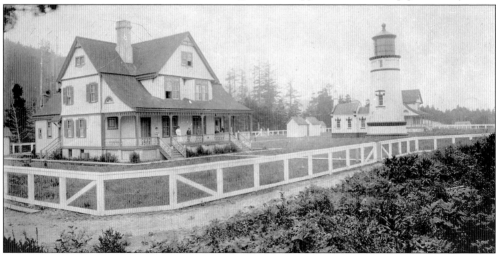

**LIGHTHOUSE COMPLEX.** This view of the Umpqua Lighthouse from the southwest shows the large wooden homes of the keeper and staff. Today, only the lighthouse proper still exists. The Heceta Head Lighthouse, Umpqua's sister, still retains a keeper's house identical to the one pictured.

**UMPQUA LIGHTHOUSE.** A c. 1900 image shows the completed lighthouse. Today, it is managed by Douglas County as both an aid to navigation and as a museum. The truly unique clear and crimson first-order Fresnel lenses draw thousands of visitors each year.

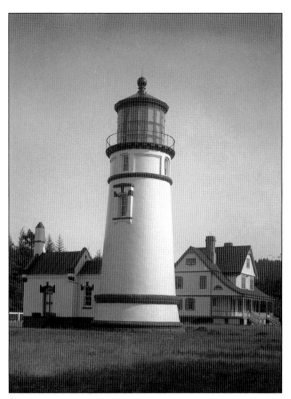

**LIVE-SAVING STATION.** Even before the construction of the second Umpqua Lighthouse, the need to aid distressed ships was addressed. In this 1889 photograph, members of a US Life-Saving Service Crew pose with women and children in front of the keeper's house at the Umpqua River Station.

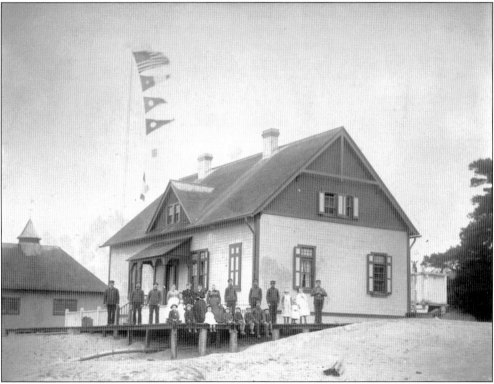

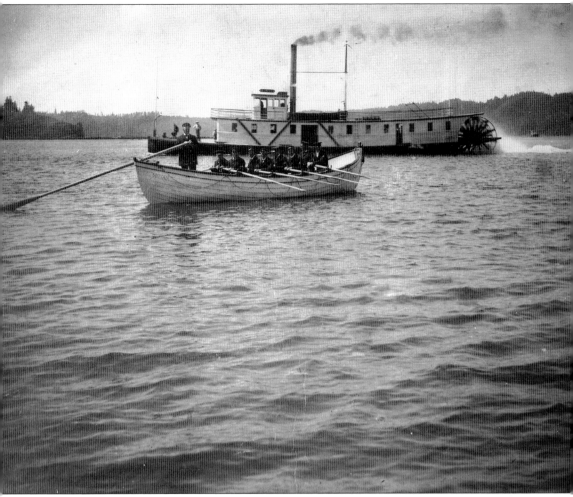

**LIFE-SAVING CREW.** Capt. John Bergman, at the steering oar, and the Umpqua Life-Saving Crew pose with the steamer *Eva* behind them. The US Life-Saving Service was a government agency that grew out of private and local humanitarian efforts to save the lives of shipwrecked mariners and passengers. It began in 1848 and ultimately merged with the Revenue Cutter Service to form the US Coast Guard in 1915.

# *Five*

# SMALL-TOWN LIFE

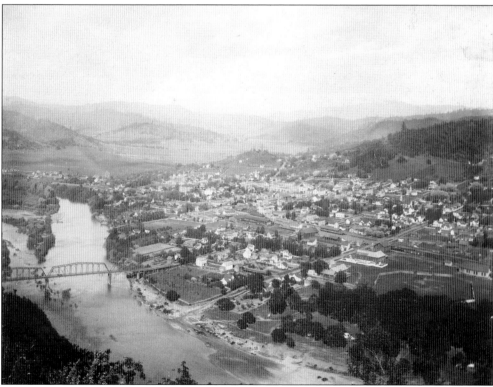

**ROSEBURG SCENE.** Taken from Mount Nebo, this early view of Roseburg was probably taken shortly after 1884 when the Lane Street Bridge was built. The three-span combination iron and wood truss bridge was built across the South Umpqua at the foot of Lane Street. Before this bridge was built, pioneers crossed the river near this site on a ferry. An old four-stall wooden railroad roundhouse and fenced baseball field can be seen at the right.

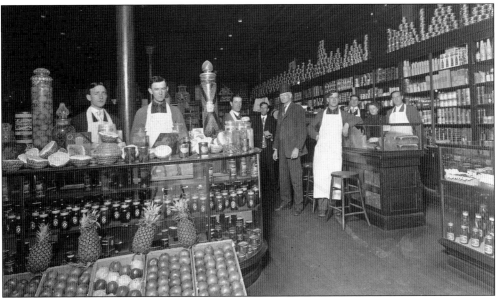

**HENNINGER STORE IN 1905.** Most impressive is the curved display case, which appears to be extremely well-stocked, along with the rest of the displays and shelves in the store. Obviously, the business employed several people, as many of the men in the view are wearing white aprons. Fresh pineapple and other produce are in view in the foreground.

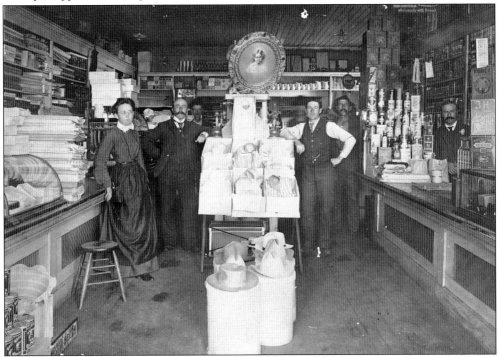

**BECKLEY STORE.** This c. 1910 interior view of the Beckley Store in Yoncalla fits the classic mold of a general store: dry goods section on the left with shelves of yard goods and ready-mades. The grocery section is at the right with a variety of canned goods visible. In the foreground are boxes of clothing and a display of men's hats. The man in the white shirt and vest is Arthur Kelso.

**Roseburg Grocer.** This is J.F. Barker and Co. Groceries, located on Jackson Street in Roseburg in 1905. An impressive display of china can be seen through the window at left and the owner, John Barker, is pictured at the far right. An advertisement in the *Roseburg Plaindealer* newspaper stated that they had a "new stock of fine china ware" as well as "just arrived—figs; honey; almonds; walnuts; raisins; currants; citron; lemon and orange peel."

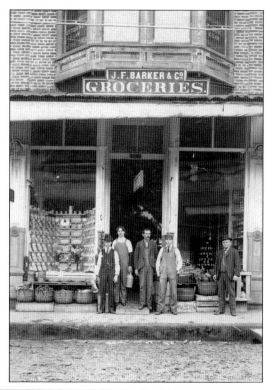

**Hometown Drive-In Restaurant.** In the 1950s, Duffy's The Barbeque King drive-in restaurant was located on North Stephens in Roseburg. The early drive-ins mixed the allure of hamburgers and milk shakes with a playful cruising crowd, and they became an American tradition that predated fast-food restaurants. Roseburg was no exception, and many teens and families came to Duffy's to show off their rides or to eat meals in their cars.

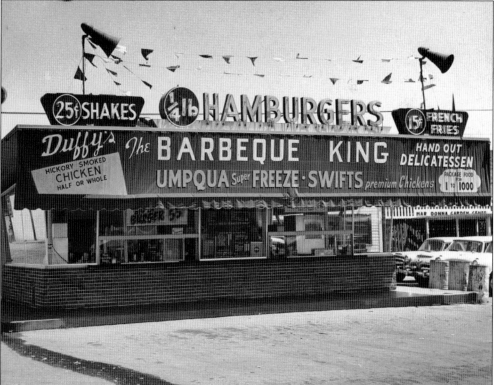

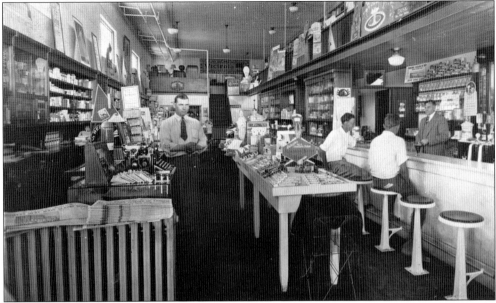

**ALL IN ONE STORE.** An interior view of the Umpqua Drug store located in Reedsport in the 1930s shows the owner, Bill Burdick, behind the counter and the druggist Jack Unger at left. Within pharmacies such as this were eating establishments known as soda fountains, serving soda beverages, ice cream, and sometimes light meals.

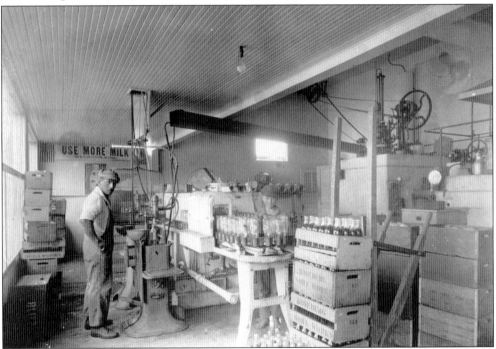

**BOTTLE WORKS.** Ernest Unrath and his son stand inside the bottling factory of the Roseburg Soda Works about 1915. The factory was located on the corner of Oak and Pine Streets. In the center of this photograph is the bottle-washing machine, operated by electric power. It washed 50 dozen bottles an hour.

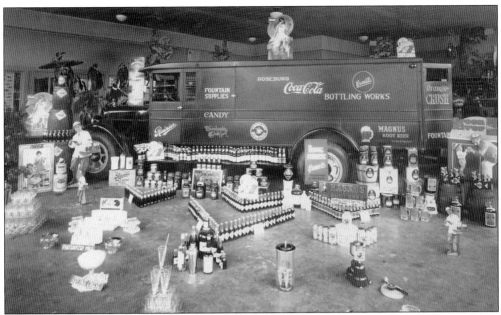

**COCA-COLA.** First created in the 1880s in Georgia, Coca-Cola was enjoyed nationwide within a decade. It was dispensed at soda shops, and it was not until 1899 that it was bottled on a large scale. Individual bottling companies were licensed to package the drink and sell it in their local markets. In this image is a display set up by Ernest Unrath's Roseburg Coca-Cola Bottling Works in the 1920s.

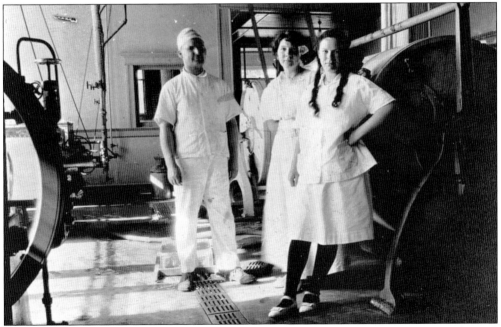

**GARDINER CREAMERY.** An unidentified man and two young women, Carolyn Schelling (center) and Ella Chambers, are standing inside the Gardiner Creamery in 1910. It was reported in a Roseburg newspaper in 1902 that this creamery produced 55,000 pounds of butter to ship to San Francisco and 4,000 pounds of cheese for home consumption.

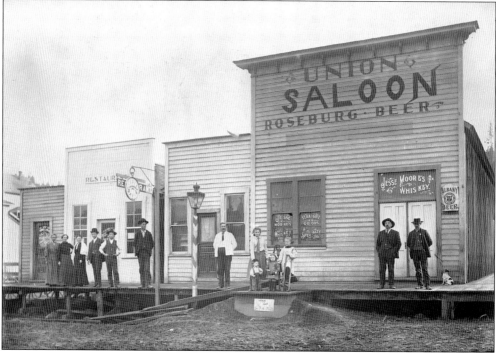

**GLENDALE STREET SCENE.** Looking like a set for a western, this view of Glendale shows a row of buildings in the business district. The proprietor of the Union Saloon, which advertises Roseburg Beer and other liquor, is pictured second from right. The barber is in front of his shop, and fifth from the left is an unidentified Chinese cook who worked in the restaurant.

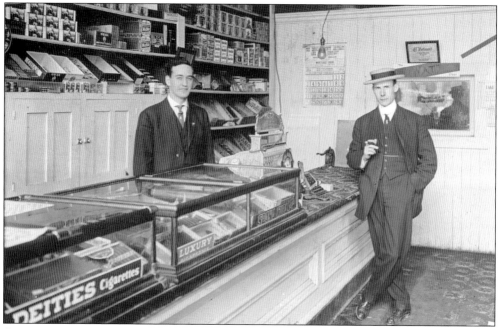

**GOODMAN CIGAR STORE.** Ross Goodman (left) mans a Roseburg cigar store, one of several such stores in town at the time. A calendar on the wall is at December 1911.

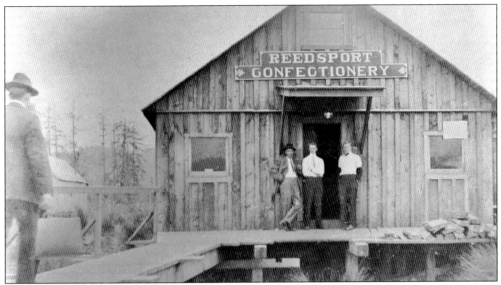

**REEDSPORT CONFECTIONERY.** As sugar became more abundant during the late 19th century, confectioneries, or sweet shops, opened up. Here, children and adults alike could purchase all sorts of candy treats. Some confectioneries contained soda fountains and even tobacco shops. This picture shows the shop in Reedsport before the town was in filled with dirt.

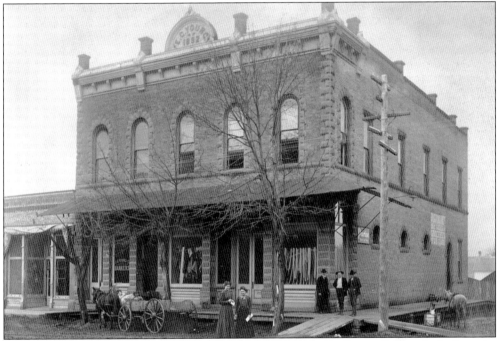

**DOWNTOWN OAKLAND.** Oakland was established about 1851 by Dr. Dorsey Baker, who laid out the townsite. When the Oregon & California Railroad reached Oakland from the north in the early 1870s, it bypassed the town by about one mile, so the entire town was relocated to the site where it is found today. This image from around 1900 shows one of the fine brick buildings constructed in the new Oakland. Today, much of the town is on the National Register of Historic Places, and Oakland is a popular antique shopping destination.

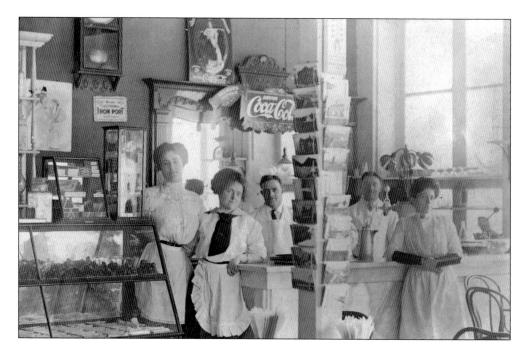

**NORMAN CONFECTIONERY.** Employees of Norman Confectionery pose near the counter and candy display case around 1905. This establishment was located on Jackson Street in Roseburg. Life appeared uncomplicated back then, when a nickel or a dime could buy a soda fountain delight or a sweet treat.

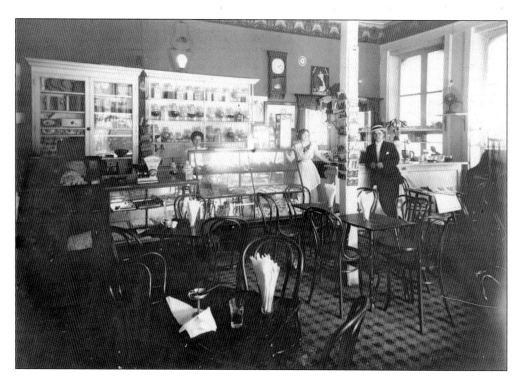

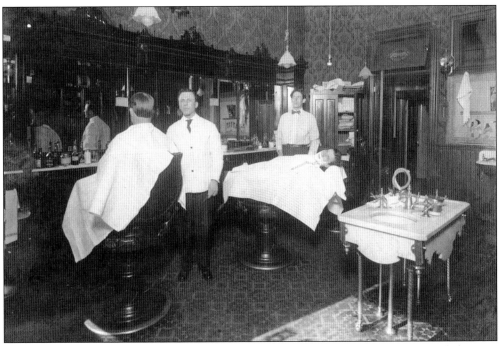

**BARBERSHOP.** One hundred years ago, gentlemen went to have a fine haircut and shave at the local barbershop, as seen in this c. 1910 image of Harrison Chenoweth's (in white coat) Roseburg shop.

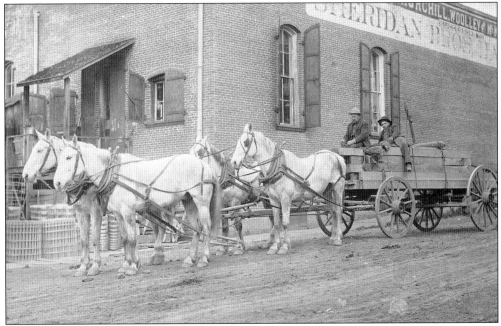

**LUMBER DELIVERY.** On Oak Street in downtown Roseburg around 1895, William Vinson and son make a delivery of lumber from Millwood, Hubbard Creek. Note the fine brick construction of the hardware store in the scene. Although Roseburg did have a brickyard, only downtown businesses readily utilized the material. Most homes were made of wood.

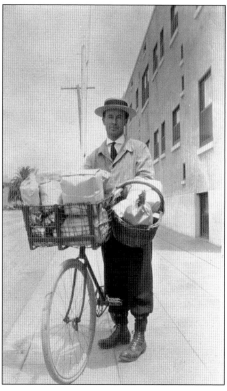

**GROCERY DELIVERY.** Many groceries and mercantiles in the late 1800s and early 1900s offered delivery service, such as in this image of Mike Daniels with his delivery bicycle and basket filled with well-packaged purchases.

**PALMER HOUSE.** A group on the porch of the Palmer House poses for a photographer in the early part of the 20th century. Palmer House was a Scottsburg hotel and stage stop long operated by Mr. and Mrs. Peter P. Palmer. A.G. Walling's *History of Southern Oregon* states that Palmer opened his noted hotel in 1884 and that it was well known for its comfort, food, and the family's hospitality. The hotel was also a terminal for the Drain & Coos Bay Stage Line, offering a free coach service to and from the steamboat landing on the Umpqua River.

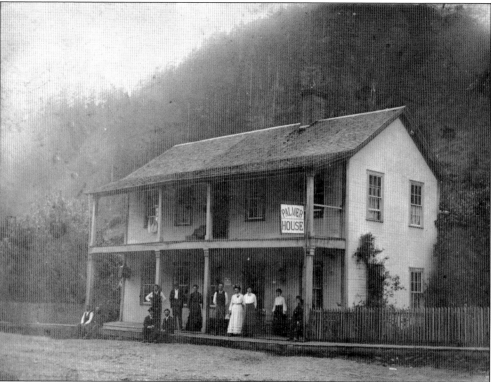

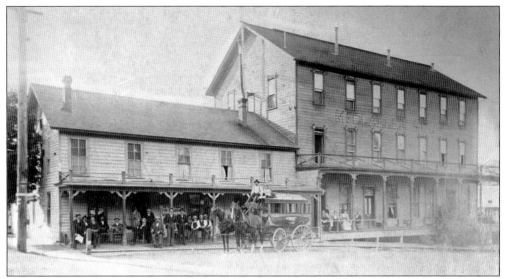

**FINE DINING.** Roseburg's American Hotel, with the McClallen House addition, is pictured with a stage in front and groups on the porches. This was one of Roseburg's largest hotels, and it had a well established kitchen and dining hall. The Thanksgiving menu in 1909 was extensive: relishes: plume celery, ripe olives, salted pecans; soup: chicken and oyster; boil: tongue with jelly; entrées: chicken giblets on toast; roasts: stuffed young turkey with cranberry sauce, beef, pork, mutton, veal with dressing; salad: shrimp en mayonnaise; dessert: hot mince pie, lemon cream pie, English plum pudding with hard brandy sauce; black coffee.

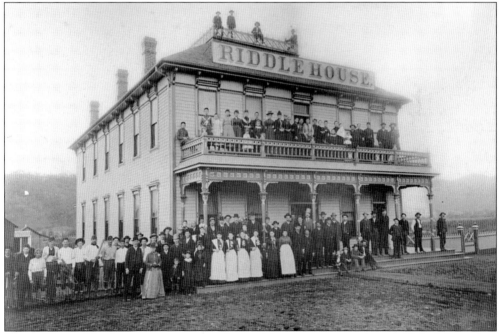

**RIDDLE HOUSE.** Hotels or taverns came into being almost as soon as settlers established themselves in Oregon. The Riddle House was an early stopping place for weary travelers passing through the southern part of Douglas County. This view taken in the 1880s shows the hotel in all its glory, with a large crowd posed on every level of the building.

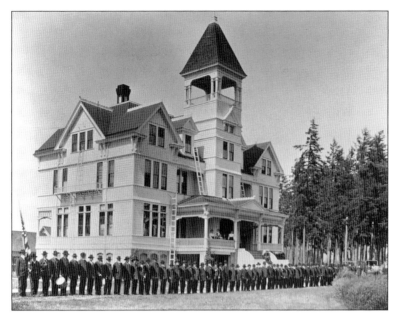

**SOLDIERS HOME.** A large group of veterans is lined up in front of the Oregon State Soldiers Home in Roseburg in about 1905. By the time this photograph was taken, there were other buildings nearby used as nursing and retirement homes. There was also care for the widows and orphans of the nation's soldiers.

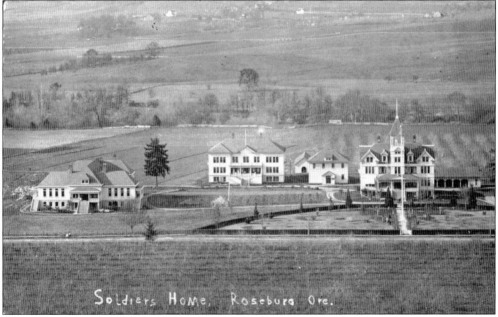

**SOLDIERS HOME CAMPUS.** Oregon State Soldiers Home in Roseburg is pictured in 1903 with the original building at left along with other large buildings located west of the first structure. Originally built in 1894, the facility was created to provide housing and hospital care for honorably discharged soldiers who had served in any US engaged war. It was also available to those who served in the Indian Wars in Oregon, Washington, and Idaho.

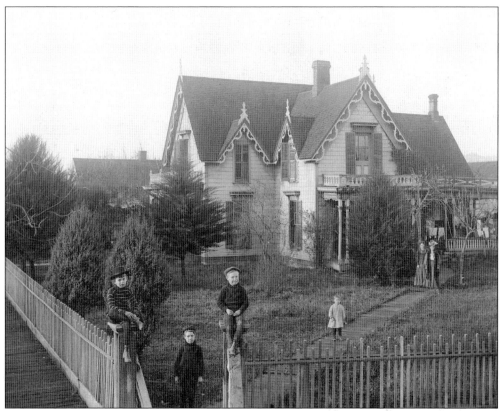

**AMERICAN GOTHIC.** The romantically styled home of confectioner L.J. Norman was located at the northwest corner of Washington and Sheridan Streets in Roseburg. Having a steeply pitched roof and many gables with decorated vergeboards, it is a fine example of Victorian Gothic Revival architecture. The view looks north, with Washington Street at the left.

**QUEEN ANNE MANSION.** Charles D. Drain's house was erected in Drain in 1895 and was the finest Queen Anne home in town. Designed in New York, the $2,600 home was then one of the most costly houses in Douglas County. It had many elegant and elaborate rooms. The first-floor included an entry stairwell and front parlor, a parlor/dining room, library, kitchen, pantry, and bathroom. The second floor consisted of four bedrooms and a corner sitting room.

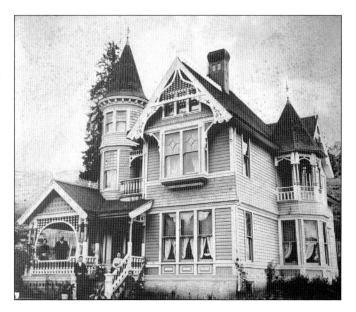

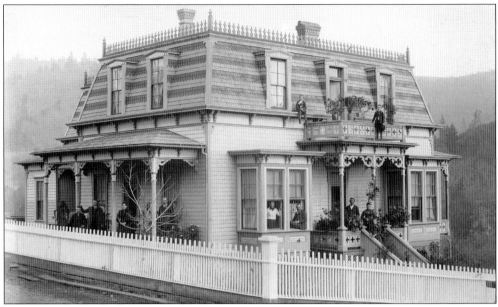

**ROSEBURG GINGERBREAD.** This house was probably located in west Roseburg, and the picture was taken by H.D. Graves, a local photographer in the late 1880s. Graves posed the family on both of the porches and peering out from the windows, and the two young boys found their precarious positions from the upstairs balcony. The most noticeable architectural feature of the house is the mansard roof, which makes maximum use of the interior space of the attic.

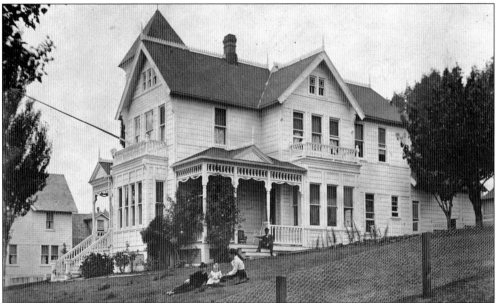

**JEWETT HOME.** This two-story Queen Anne–style house was originally constructed for and used as a residence by W.F. Jewett in 1886. It was one of the most outstanding homes in Gardiner and remains so today. With the delicately turned posts on the porch and balcony rails and fish scale–patterned shingles covering the gable walls, the house has a handsome and decorative appearance. W.F. Jewett was a native of Maine and was the vice president and general manager of Gardiner Mill Company.

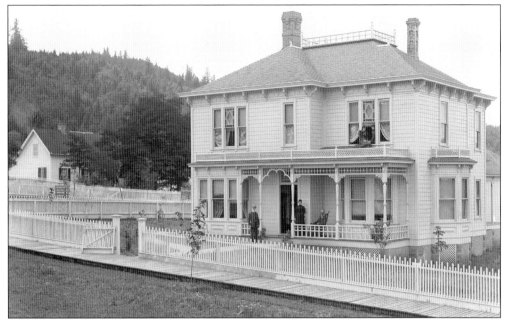

PAGE HOME. Dr. Edward and Theresa Page's home located in Oakland was a fine example of Queen Anne architecture. The photograph was taken in 1892 by the local photographer Timothy Graves. By the 1880s, Oakland had emerged as the leading community in northern Douglas County. Development peaked by 1890, but the foundations of the town were shaken by a disastrous fire in the commercial district on July 4, 1899.

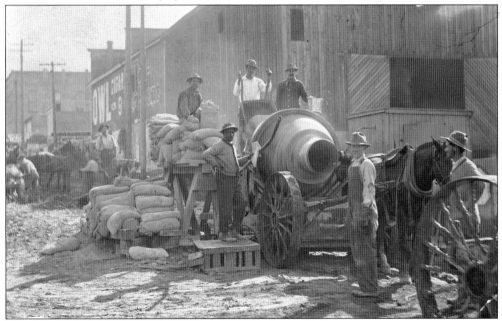

ROAD CREW. This view looking east on Oak Street in Roseburg shows a street-paving crew with horse-drawn dump carts and a cement mixer. In 1909, Jackson Street was the first street to be paved in town, and later Main, Cass, and Oak were surfaced with the new concrete mix. These new roadbeds provided great relief from the dust and mud.

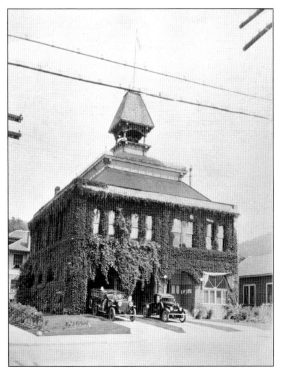

**CITY HALL.** Roseburg City Hall is covered in vines in about 1925, with a Reo fire engine and a classy coupe parked in front. The structure was built in 1892 on the southeast corner of Main and Oak Streets. The lower floor included the recorder's office, a three-cell jail, a large room for firefighting equipment, and, 30 years later when this view was taken, the motorized fire trucks. The second story contained the firemen's room, a council room, and the city marshal's office.

**FIREMEN.** Two Roseburg firemen pose with a hand-drawn hose cart inside Roseburg City Hall in the 1890s. The ladder wagon is pictured at left, and the large arches are distinctive of the structure, which was designed by Roseburg architect G.W. Orcutt and built by local contractor J.A. Perkins at a cost of $6,900 in 1892.

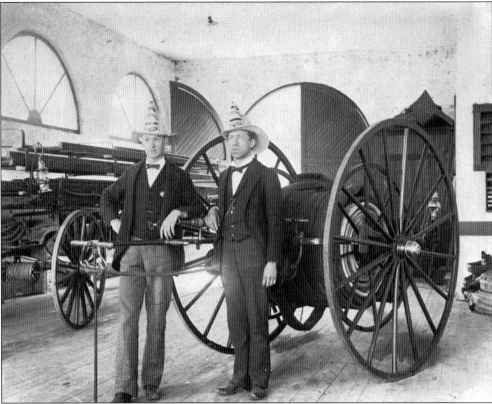

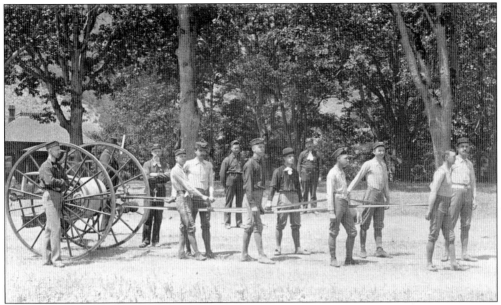

**FIRE DRILLS.** Here is the Roseburg Fire Department Hose Team practicing in an oak grove in Roseburg in the 1890s. The first propulsion means for these early pumps, whether they were hand- or steam-powered, consisted of human beings pulling the pumps. In some cases, by the time the firefighters got to the scene, they were already worn out.

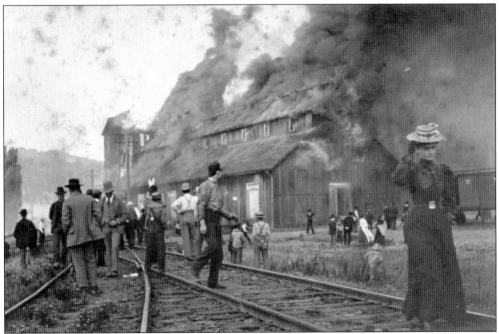

**WAREHOUSE FIRE.** The S. Marks & Co. grain warehouse and elevator in Roseburg caught fire at 2:30 p.m. on June 29, 1898. Caused by sparks from a passing railway engine and fanned by high winds, the fire burned rapidly. The roofs of many nearby buildings also began to burn, but none was seriously damaged. The loss to S. Marks & Co. included the grain machinery and about 1,000 bushels of wheat.

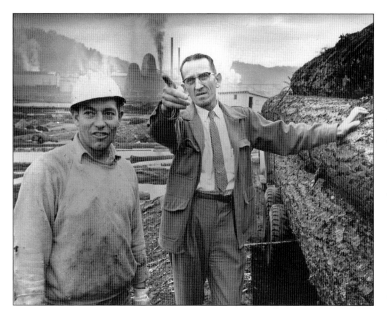

**ROSEBURG LUMBER.** Kenneth Ford (right) stands by a log truck with an unidentified employee at his sawmill in Dillard in 1959. Ford founded Roseburg Lumber Company in 1936. It produced quality wood products for customers throughout North America. In 1985, it was organized as Roseburg Forests Products Co. and is one of the largest private lumber companies in the United States.

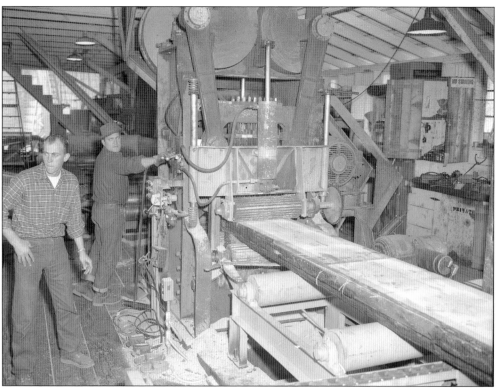

**SAWMILL INTERIOR.** The products of Oregon sawmills went into building the community's houses, businesses, and schools, and export sales supported the development of ports and railroads. The seemingly inexhaustible forests fostered the dominance of wood in building construction well into the 1950s, when this Douglas County sawmill interior shot was taken.

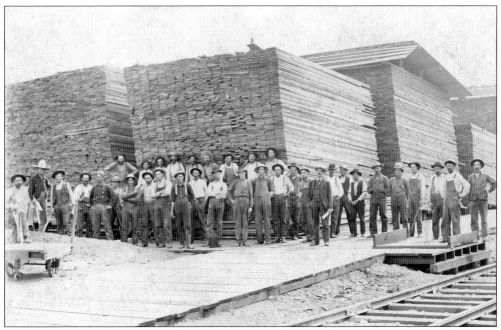

**LUMBER CREW.** These workers take a short break at the Lystul-Lawson sawmill and planing mill to pose for this c. 1912 photograph. Located near Glendale, this facility was typical of the open-air mills located near cutting sites in the Douglas County forests. Judging by the big crowd pictured, the mill had plenty of employees to maintain the engines, run the saws, and stack the lumber.

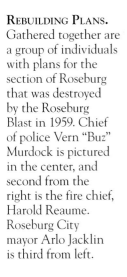

**REBUILDING PLANS.** Gathered together are a group of individuals with plans for the section of Roseburg that was destroyed by the Roseburg Blast in 1959. Chief of police Vern "Buz" Murdock is pictured in the center, and second from the right is the fire chief, Harold Reaume. Roseburg City mayor Arlo Jacklin is third from left.

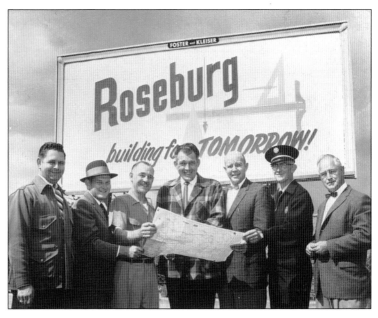

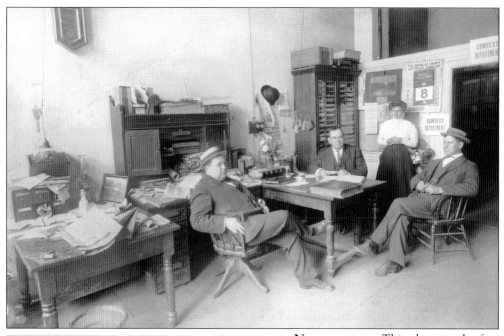

**NEWSPAPERMEN.** This photograph of the news department at the *Roseburg Review* shows some of the employees who undoubtedly were devoted to giving their readers the fullest, best arranged, and most readable history of the occurrences of the time. The calendar on the wall reveals the date— June 8, 1910. Also note the sign on the wall that reads "Contest Department." Louis F. Reizenstein is pictured at left, and across the table is M.M. Miller. The other two are unidentified.

**AGNES PITCHFORD.** Roseburg newsstand operator and *Oregonian* agent, Pitchford posed for this picture dressed in a costume made up of *Oregonian* newspapers for the Strawberry Carnival in 1913. She later became a county juvenile officer and the founder of the Pitchford's Boys Ranch, a home and school for troubled teens.

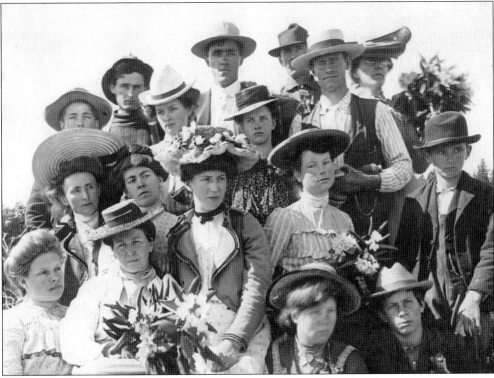

**HATS GALORE.** In this late-19th-century photograph is a profusion of hats on both young women and men alike. Millineries and haberdashers supplied fashionable hats to women and men respectively. During the Victorian and Edwardian eras, ladies hats became elaborate, with ribbons, flowers, and feathers.

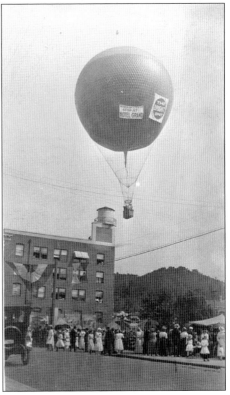

**UP IN THE AIR.** An attraction of the 1913 Strawberry Carnival was a tethered balloon that gave rides to thrilled visitors. The balloon rose on 1,000 feet of cable from the corner of Cass and Stephens Streets to give a rare aerial view of Roseburg. A *Roseburg Review* reporter who made the trip wrote rapturously, "What a rare schooling, what a priceless privilege, how broadening, how helpful!" The same balloon carried three intrepid local men on a free flight lasting more than a day. They drifted over Glide and the Bohemia area, finally landing in Hoaglin (Idleyld Park).

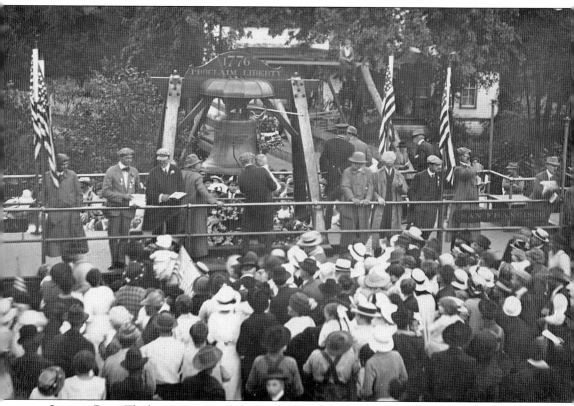

LIBERTY BELL. The longest patriotic pilgrimage ever made by the nation's most precious relic began its first journey west of the Mississippi in February 1915. The bell was loaded onto a railroad car in Philadelphia and headed to San Francisco. The bell passed through Douglas County in July 1915 and was viewed by an estimated 8,000 people, who perched on fences and cheered as it went by. This photograph was taken as the bell traveled through Drain, where the train slowed to four miles per hour so all could see. Because of additional cracking, this was the last journey for the bell.

# *Six*

# RAILROADS

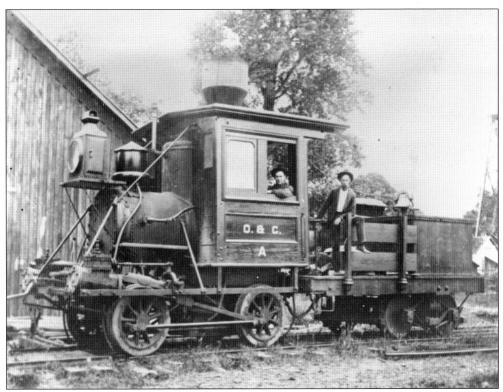

**OLD BETSY.** O&C Engine A, commonly known as *Old Betsy*, was purchased by Ben Holladay in the 1890s for construction of the Oregon Central Railroad. *Old Betsy* was the original Cascades Portage Railroad Locomotive, pulling a flatcar to the main railroad line located two miles west of Scio.

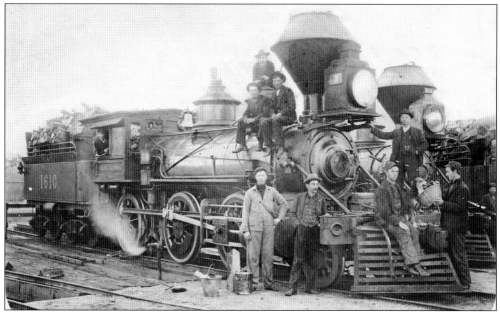

**ENGINE 1610.** O&C Engine 1610 is stopped with a load of wood and several men posing in front of it. The coming of the railroad changed all of America and was the major driving economic force all over the West. Travel of goods and people that had taken days could now be accomplished in hours. A whole new wave of immigration occurred from East to West as people sought to take advantage of the many opportunities the region promised.

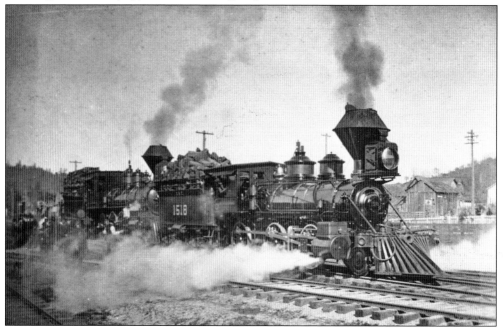

**TRAIN TOWN.** A 2-6-0 diamond stack wood-burner is re-railing another engine, possibly near the Roseburg roundhouse, in this 1890s photograph. Before timber became king, Roseburg was a railroading town, with many men working for first the Oregon & California and then the Southern Pacific line. The museum's first director, George Abdill, was a railroad engineer.

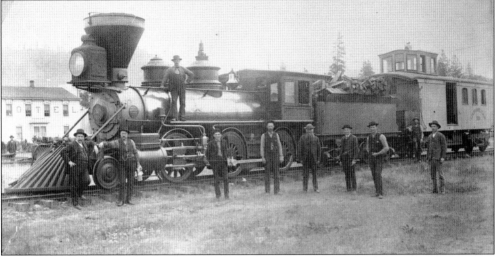

**SIGN OF THE TIMES.** The appearance of the railroad in Douglas County eventually brought about the end of travel by stagecoach on the Portland-Sacramento line. The Oregon & California Railroad was completed from the north to Roseburg by 1872. For 10 years, with construction at a standstill, Roseburg was the southern terminus of the line, and stagecoaches provided connecting transportation to California. By the time this picture was taken in 1884, the line had been completed to Glendale, which is where this engine is stopped.

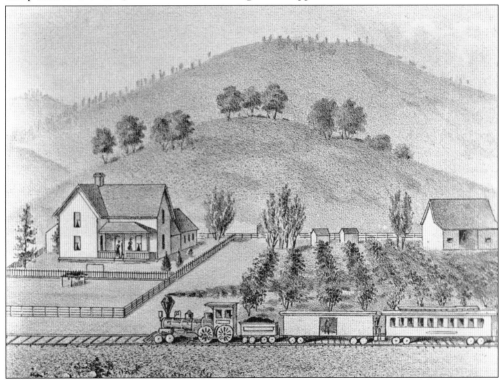

**ILLUSTRATED HISTORY.** This c. 1880 engraving from Walling's *History of Southern Oregon* is an artist's rendering of the tidy, well-organized, and apparently prosperous I.B. Nichols farm in the Cow Creek Valley. Note the two-story farmhouse, out buildings, and young orchard.

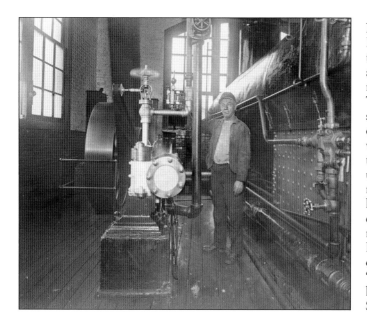

POWERHOUSE. Mike Devaney is shown here in the stationary boiler room at the Roseburg railroad roundhouse about 1920. The boiler at the right supplied steam for the engine in the foreground, which provided power for the shops and the pumps used to keep the trains running. The brick building housing the plant was torn down when diesel engines replaced steam locomotives. Devaney was awarded a commendation for running "the cleanest and best kept engine room on the Southern Pacific System."

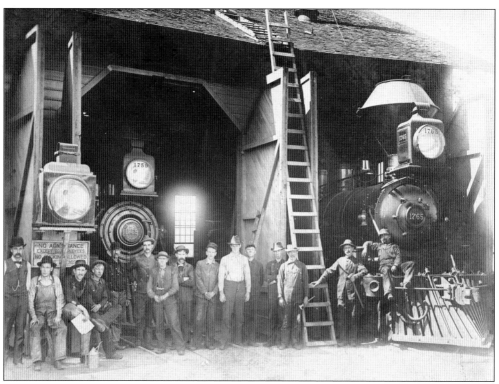

FIRST ROUNDHOUSE. A group of men is shown standing in front of the Roseburg roundhouse in the 1890s, along with engines 1759 and 1756. During the late 19th and early 20th centuries, hundreds of men who lived in Roseburg worked for the Southern Pacific Railroad.

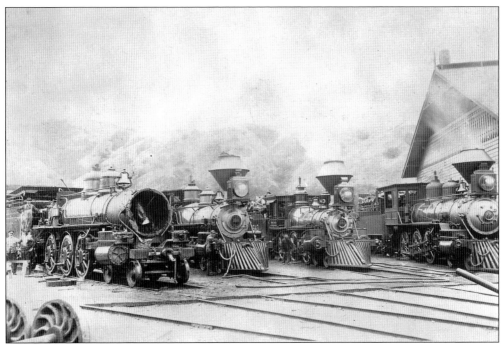

**ENGINE ROUNDUP.** Oregon and California Railroad engines 1068, 1355, 1543, and 1773 are waiting at the Roseburg roundhouse. While railcars still come along the same O&C/SP lines, the traffic is much diminished. Much of the local traffic is from cars hauling out Roseburg Forest Products lumber.

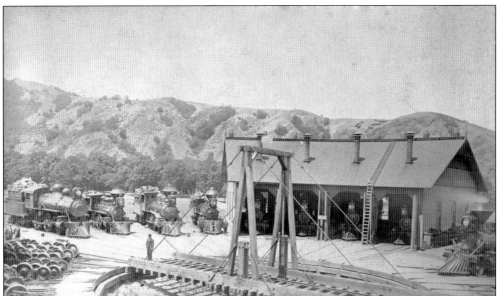

**CLASSIC ROUNDHOUSE.** Mount Nebo rises in the background of this 1899 view of the Roseburg Southern Pacific Roundhouse. The wooden structure in the foreground is the gallows turntable, and behind it is the four-stall engine house where the engines received anything from minor service to major repair work. This roundhouse could not meet demand, and a much larger brick structure was built a few years later.

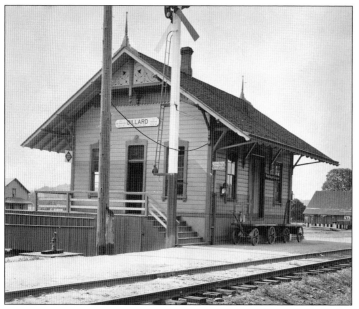

**DILLARD DEPOT.** This is the last standing of a series of identical railroad depots that dotted the Oregon and California landscapes. In the 1980s, the Dillard Depot was donated by Roseburg Forest Products, which owned it at the time, to the Douglas County Museum, where it has been fully restored and is open for visitors to tour.

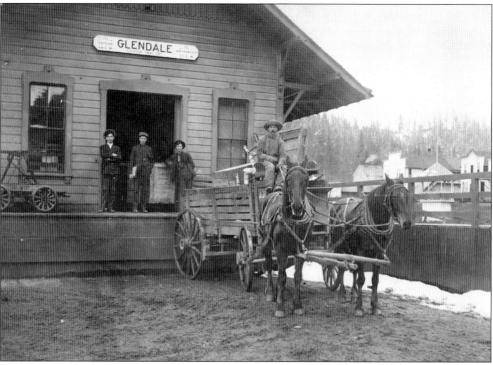

**DRAYMAN.** When the railroad replaced the freighter's wagon and the pack train in transporting merchandise to Douglas County towns, a new local occupation was born: that of the town draymen. The town railroad depot formed the heart of many communities, for it was here that passengers arrived and departed and the freight for local merchants was delivered. In this photograph, J.O. Jones, a local drayman, is at the Glendale depot after having loaded his delivery wagon with goods destined for the town merchants. The false-fronted buildings of Glendale's business district can be seen at the right in this 1905 scene.

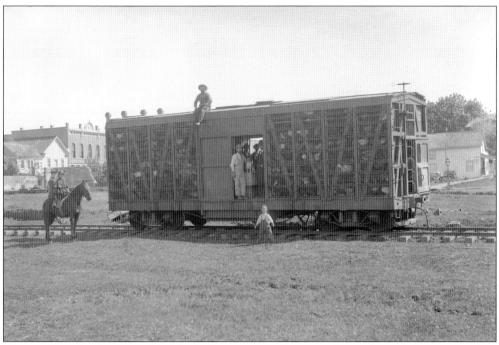

TURKEY CAR. Railroads enabled fresh farm crops to be shipped quickly and cheaply to urban markets. In this 1890s photograph in Oakland, poultry is all loaded and ready for shipment. By the Second World War, turkey production became huge in the area to the point that Oakland was known as the Turkey Capital of the West Coast.

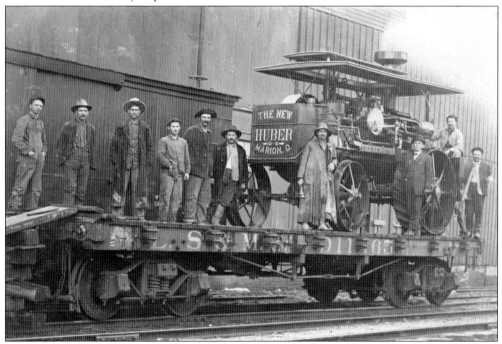

EQUIPMENT FREIGHT. Trains not only hauled out agricultural products but they also brought in the latest farm machinery from back East, such as this steam traction engine from Ohio.

**FANCY TRAVELER.** This 1898 view shows the Roseburg train depot. The woman and child to the far left are Bessie Riddle and Margaret Crosby. In the middle of the photograph is Julius Riddle standing in front of Bouseman Crosby. The man at the right is David Crosby.

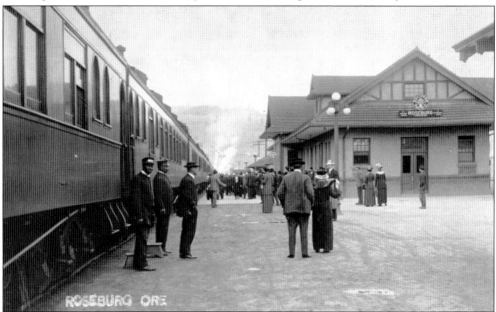

**ROSEBURG STATION.** A crowd is gathered on the platform of a Southern Pacific passenger station sometime between 1910 and 1915. The train at left is headed northbound from Roseburg and would continue north to Portland, the end of the railroad line. The Roseburg depot is the present-day site of McMenamins Roseburg Station Pub & Brewery.

**WEST FORK HOTEL.** This is West Fork Hotel as it appeared in the 1890s. West Fork is in the Cow Creek Canyon in southern Douglas County on the Southern Pacific Railroad. This board-and-batten building accommodated many Southern Pacific railroad men with a nice home-cooked meal and a room. When this hotel burned in the early 1900s, a temporary "Hotel Camp" was set up until another lodging was built to replace it.

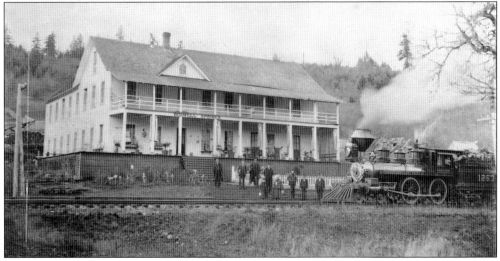

**RAILROAD RESORT.** Boswell Springs Hotel, located in the Yoncalla Valley on the Oregon & California (later Southern Pacific) Railroad is shown here in the 1890s when the Springs Hotel was operating on the line with an early O & C engine still in use. The resort featured mineral baths, believed to have beneficial medical effects. The hotel burned in June 1908.

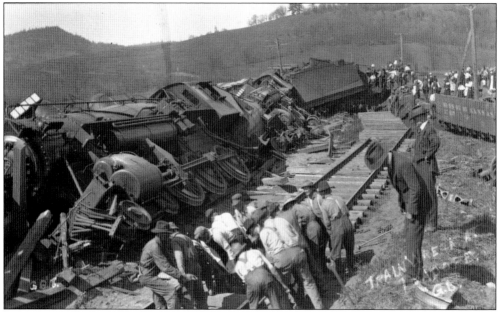

**TRAIN WRECK.** A group of unidentified men is gathered around a Southern Pacific train wreck at Isadore, south of Rice Hill, in 1918.

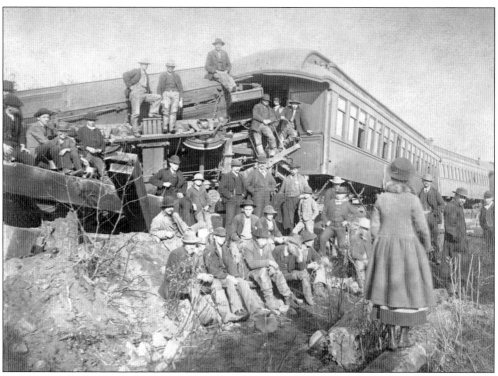

**COMMUNITY HAPPENING.** Train wrecks were considered a big happening that would bring a whole community out to see the damage. A large crowd is gathered around the aftermath of a wreck just north of Oakland in this photograph taken November 12, 1890.

# *Seven*

# CHILDREN'S LIFE

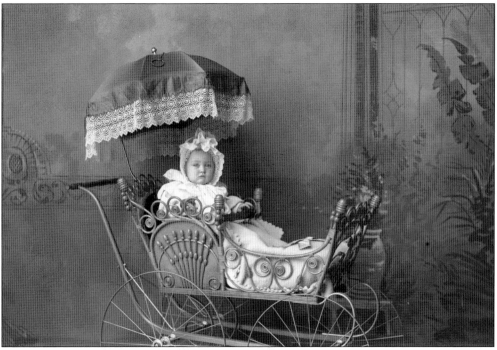

**VICTORIAN BABY.** Ruth Chenoweth sits inside a baby carriage shaded by a fancy parasol in this studio photograph taken in the early 1890s. Her elaborate bonnet was a characteristic accessory for a baby ready to have its portrait made. With its pretty bow and scalloped edging, the blanket in the carriage would have done double duty, keeping off the chill and also acting as a prop. The Douglas County Museum now has this carriage in its collection.

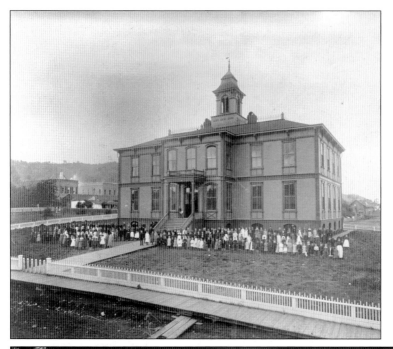

**LANE SCHOOL.** The second Roseburg Public School built in 1888 is seen here in the 1890s. Note the wooden sidewalks along the street in front of the school. The school was later added on to with two rear wings to accommodate the growing town's students. In the schoolyard, a large collection of teachers and students poses, while a drummer stands at the top of the front steps.

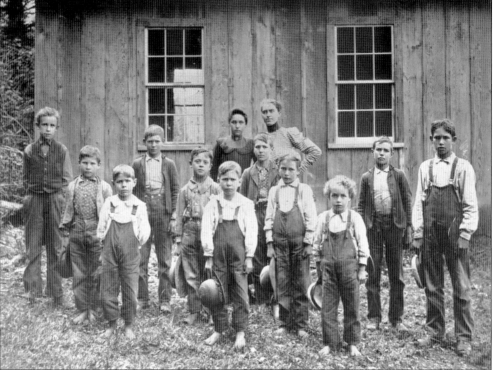

**FARM SCHOOL.** These students stand in front of Edenbower School around 1900. Abbie Parrott (pictured at the top right) was the teacher. Edenbower adjoined the Roseburg city limits northwest of town. Most of the people who lived in the area were farmers, and most of the land was divided into orchard tracts.

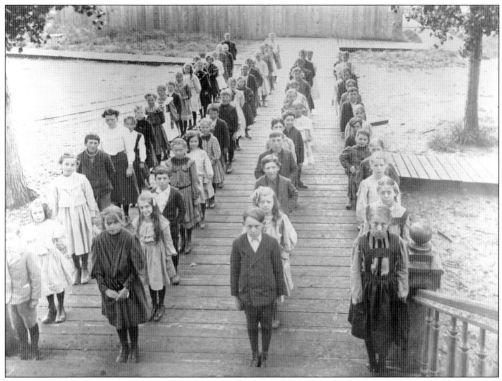

**STRAIGHT LINES, PLEASE.** Discipline was a serious matter in turn-of-the-century education. Students were expected to form straight lines at the beginning of the day and march to their classes. Paddles were at the ready to handle any disruptive children. These students are at the old Lane School in Roseburg.

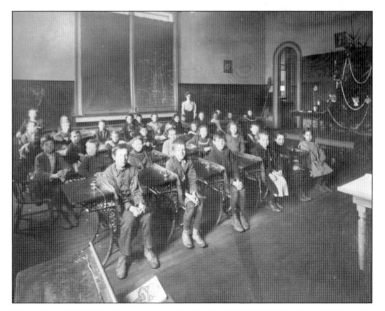

**HOLIDAY CLASSROOM.** Public education was changing a great deal around 1900, but reforms and improvements were slow to trickle down to small-town schools. This is a view of a Lane School classroom about 1900. It was undoubtedly the month of December as a drawing of Santa Claus is on the blackboard, a Christmas tree is at right, and the students are wearing coats.

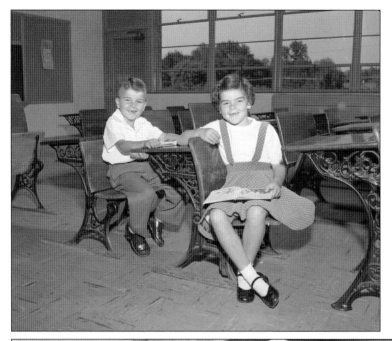

**READY TO LEARN.** A mid-1950s grade school such as this one, photographed one September, brings to mind freshly waxed floors and washed windows, new paper and pencils, and, of course, new students. Sitting at desks, which were the same style as those used half a century earlier, these two unidentified Roseburg children have their books open and look ready to learn.

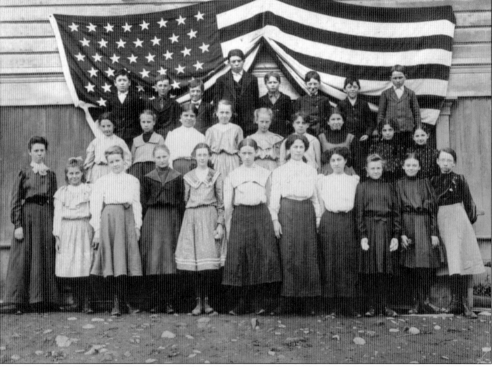

**CLASSIC PICTURE DAY.** Class pictures have been a staple since soon after cameras were invented. This group is showing its patriotism with a large 45-star flag draped behind the fifth-grade class at Lane School. Edith Aldrich (Falbe) was the fifth-grade teacher in 1906. Most teachers of the era were either not yet married or spinsters, as women were not typically allowed to continue teaching after they married.

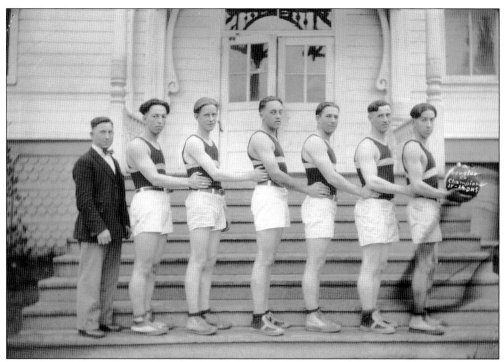

**TEAM SPIRIT.** This is the Drain High School boys' basketball team and coach. The team was Douglas County champion during the 1925–1926 school year. From left to right are Coach Cochran, Joe Leonard, Bernard ?, Hugh Anderson, Fredrick Safley, Lloyd Coons, and Clark Bartholomy. The same year that this team had such huge success, the American Basketball League was created, ending a short nationwide slump in basketball enthusiasm.

**FASHIONABLE ATHLETES.** A girls' basketball team poses for a photograph in 1904. They are, from left to right, Mertie Bales (Bullwindle), Aire Black, Elsie Benedick (Mrs. Jesse Hicks), Olivia Risley (Carnes), and Hazel Jewett (Dixon). Less than a year after basketball was taken up initially as a men's sport, high school teams for boys *and* girls became the new trend. Especially in Douglas County, it could be appreciated in the early 1900s as a way for young people to stay active—and dry—during the rainy winter months.

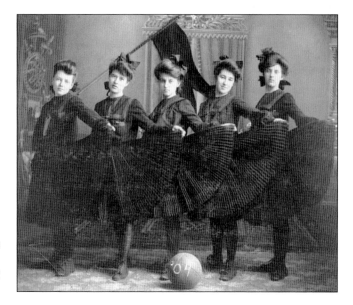

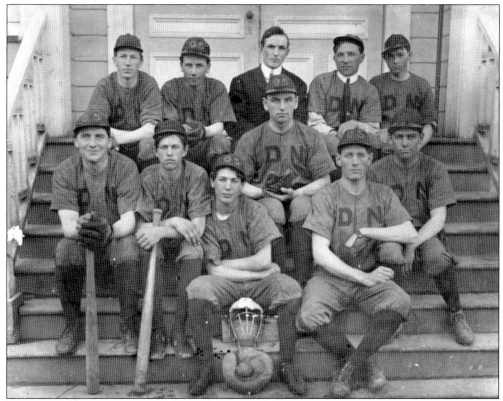

**ALL-AMERICANS.** By the early 20th century, baseball had established itself as a national pastime. The Drain Normal School baseball team sits together, possibly with its coach, on a small flight of steps. Pictured here from left to right are (first row) Strung Moore, and Oliver Beals; (second row) Ernie Whipple, Roscoe Gardner, Lloyd Whipple, and Harry Moon; (third row) unidentified, Harry Black, unidentified, George Nenner, and ? Cellars. Each of the boys wears a hat with "05" on it.

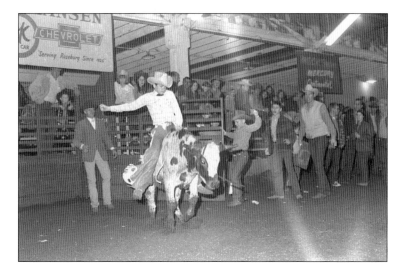

**RIDE 'EM, COWBOY.** An excited crowd looks on in this photograph as an unidentified young man holds onto a steer. Another boy closes the chute gate behind him. This was the Douglas County Fairgrounds in April 1971, and the boy on the steer is a participant in the Junior Jackpot Rodeo.

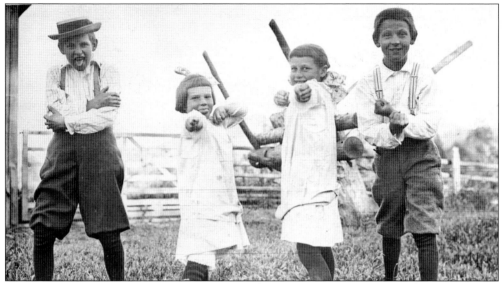

**BECKLEY CHILDREN.** These four children have paused their game to pose in front of the camera one sunny day in Oakland. From left to right, Leo, Lois, Vesta, and Lynn Beckley are the children of Pitzer Beckley. In 1910, when this photograph was taken, children often created their own games with their friends and siblings.

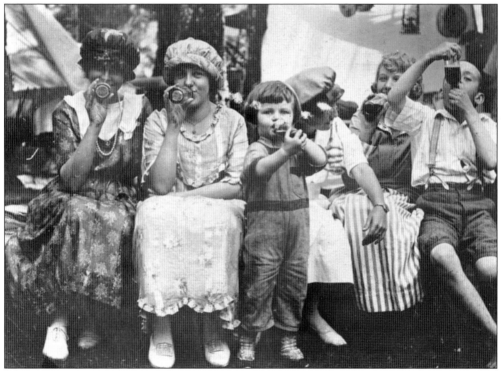

**PAUSE THAT REFRESHES.** Even the hardworking children of the early 20th century found time to take a break and relax. This group is enjoying soda pop together at Weber Camp located at Rock Creek. They are, from left to right, Maude Weber, Elza Weber, Phillis Ann Bolter, Kathleen Bonebreak, Iris Rice, and Henry Weber.

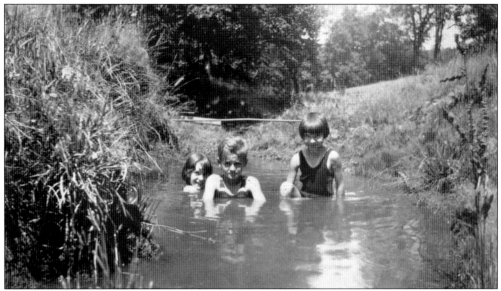

**Swimming Hole.** Three children wade in the water at Halo Creek near Yoncalla around 1928. This photograph was taken at the part of the creek located in the back of the Sumner Brawn Jr. farmhouse and was the original Lindsay Applegate donation land claim property. Pictured from left to right are Dorothy Williams Long, Don Kresse, and Betty Kruse Smith.

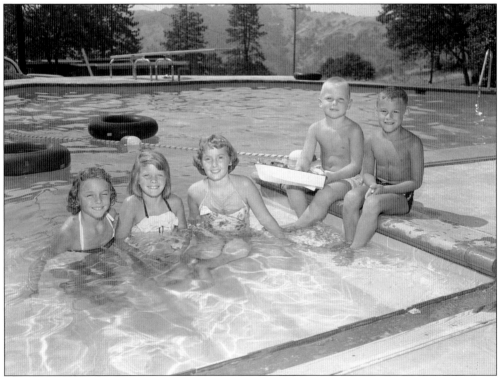

**Pool Time.** These five Douglas County children cool off on a hot summer day in Hawthorne Pool. Swimming in streams and rivers especially in areas near town was considered dangerous by many, and such pools provided safe chemically cleansed recreation.

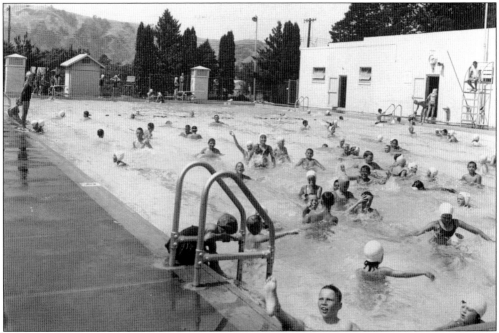

**Public Rec.** Following World War II, many towns began adding public swimming pools for area children. Located between southeast Jackson and southeast Hamilton Streets, the Roseburg Municipal Swimming Pool was many children's—and adults'—favorite place to spend the summer. In this view from the 1950s, an energized crowd of people is having a good time swimming and splashing in the water. Years later, the pool was destroyed.

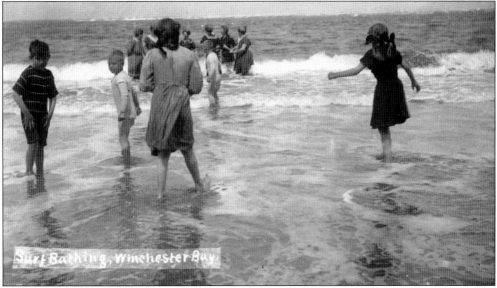

**Hitting the Surf.** With the wind whipping and the salty ocean water gliding onto the sand, these children are enjoying the beach together at Winchester Bay. They are wearing the common swimwear of the early 1900s: the boys in shirt-and-shorts bathing suits and the girls in dress bathing suits. Beyond the children in the foreground, a group of women—probably their mothers—can be seen in the surf.

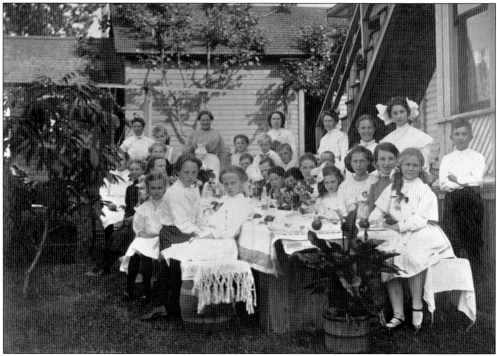

**PARTY TIME.** A children's party is being held in the early 1900s in Roseburg. The children are all wearing their best, the boys in fancy suits and the girls in white dresses. Some of them even have huge bows in their hair. At the far end of the table, a few adults can be seen standing. This party was held in the backyard of Max Weiss, who owned the Roseburg Brewing and Ice Company.

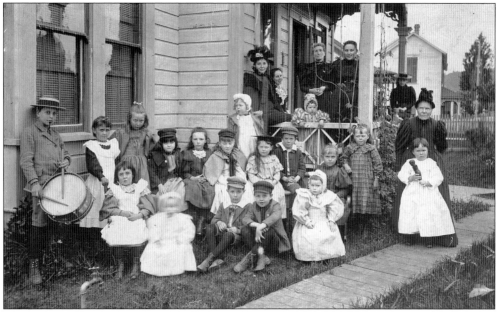

**PARTYGOERS.** An H.D. Graves photograph shows the scene of a children's party in the 1890s. Five or six adults look out over the porch, and 18 children sit and stand outside of a house in Roseburg. The boy at the far left is carrying a drum in this group of children of various ages.

**THEATRICAL POSE.** This spoof on dentist's office by children is titled "Phillips and James, Dentists." The studio photograph is by Oakland photographer Timothy Graves. Children were often posed in whimsical scenarios on elaborate sets such as these by professional photographers.

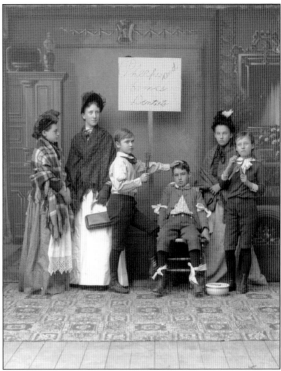

**HEADED HOME.** The patient, tired oxen do not object to their young riders because they know the yokes will soon be taken off their tired shoulders, and they will be led to a manger of sweet hay. This was G.F. Pike's ox team in the late in the late 19th or early 20th century.

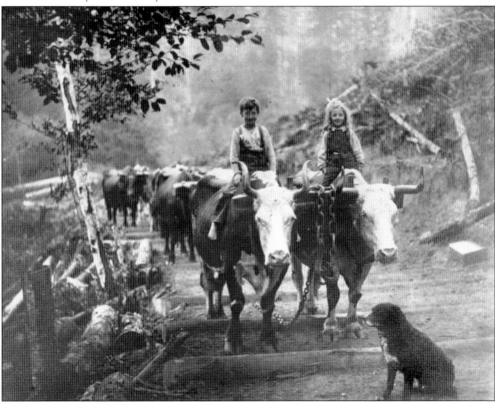

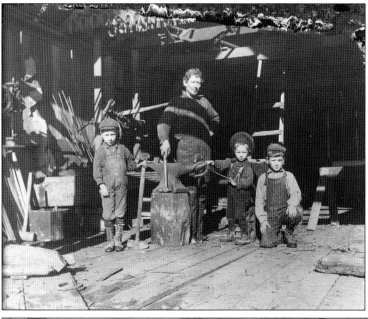

**BLACKSMITHS-IN-WAITING.** Alva Brown and his three sons are pictured in his blacksmith shop located in Camas Valley in about 1910. Camas Valley is an unincorporated community located near the Middle Fork Coquille River and named for a favorite food of many western Indians, the camas bulb. Many children followed their parents into the family business and started informal apprenticing at very young ages.

**PICTURE PERFECT.** These three children sitting on a porch together in Yoncalla about 1903 are Vivian (last name unknown), Dolph Samler, and Hazel Samler. The Samler girls were the children of John and Lucy Burt Samler. Vivian wears a jabot at her collar, Hazel wears a long necklace, and both of the girls have large, decorated hats typical of the time. Dolph is still of the age where boys wore dresses, and he has a small cap on his head.

**STUDIO PORTRAIT.** An H.C. Mackey studio photograph shows sisters Lela (left) and Corda Medley, heads tilted together. They were two of the children of John Robert Medley of Oakland, who was involved in what may have been either the Indian Wars or the Civil War.

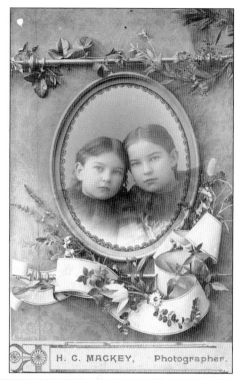

H. C. MACKEY, Photographer.

**MIGHTY HUNTERS.** Three Denn brothers sit on top of a bear cub's body in 1904. They are, from left to right, Bernard L., age one; Victor, age five; and Lawrence, age three or four. Bernard graduated in 1920 from Camas Valley High School. The boys may have been at Camas Valley at the time this photograph was taken.

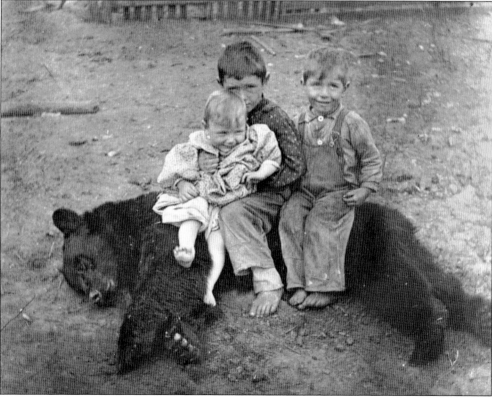

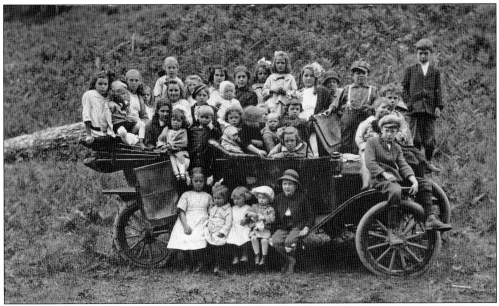

**FULL CAR.** An automobile filled with children is the focus of this photograph taken in 1916. Stopped in Olalla, a small community between Tenmile and Camas Valley, this was supposedly the first car in Douglas County. The child in the white cap sitting on the running board is Bernice Fisher, who would later marry William Frank Sumstine.

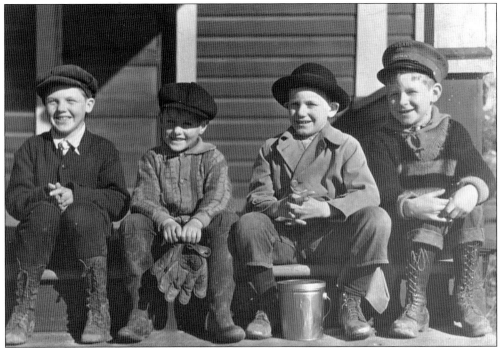

**BOYS' LIFE.** Pictured from left to right, Marvin Helland, Earl Reese, Joe Hollaman, and Claude Daugherty smile for the camera on the steps of a house in 1926. With a baseball glove and a bucket, these Yoncalla boys are ready for a ball game, climbing an apple tree, or maybe a hike up the hillside.

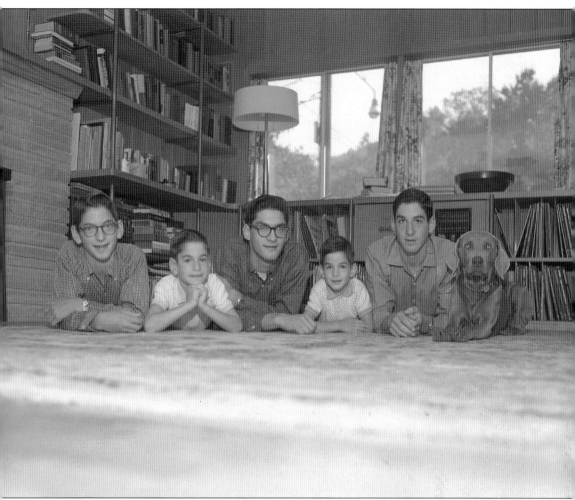

**SOHN BOYS.** The Sohn boys and dog pose on the floor together in their home in this 1950s image. Their father, Fred Sohn, started the Sun Studs Sawmill in Douglas County in 1949, the year that the family moved to Roseburg.

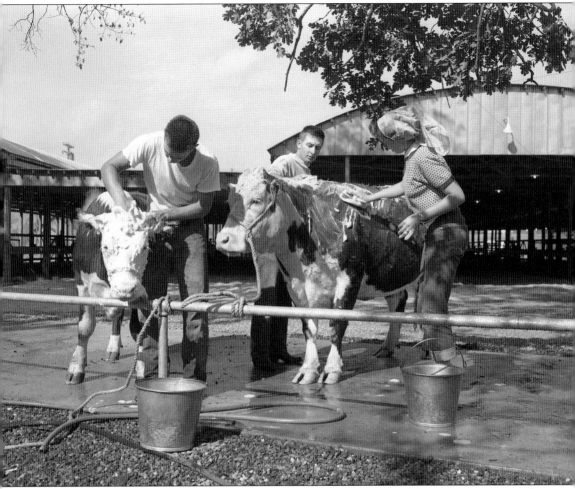

**CLEAN BEEF.** These two steers enjoy a moment of being groomed by their owners, preparing the stock to be shown at the Douglas County Fairgrounds about 1960. The owners are most likely Future Farmers of America or 4-H members. With roots in Oregon dating back to the early 20th century, FFA and 4-H have had a long history in Douglas County of getting kids of all ages involved in their community and their local economy.

# *Eight*

# LEISURE TIME

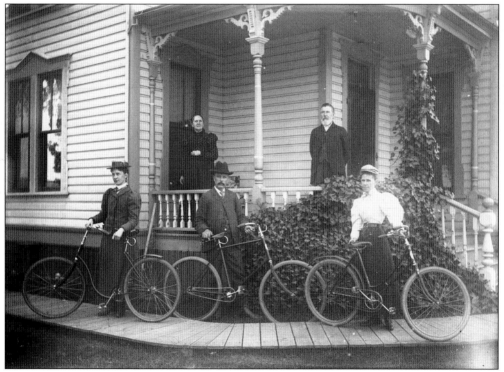

**BICYCLE ENTHUSIASTS.** This group of three people has decided to go on a bicycle ride near the Beckley house in Oakland. With the improvement of the safety bicycle, which included a chain drive, as seen in this 1890s picture, bicycling quickly became all the rage—in both the city and the country and for men and women alike.

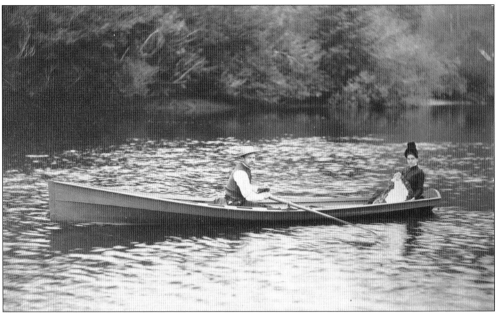

**BOAT TRIP.** Before roads and bridges were built, boats and ferries were the typical means of traveling through and across water. In Douglas County, they were an especially important form of transportation, with the Umpqua River and its tributaries being an integral part of everyday life. This 1888 photograph shows Robert Ashworth, Francis Ragon Ashworth, and the couple's infant daughter, Maude Ella, in the family skiff on the Smith River.

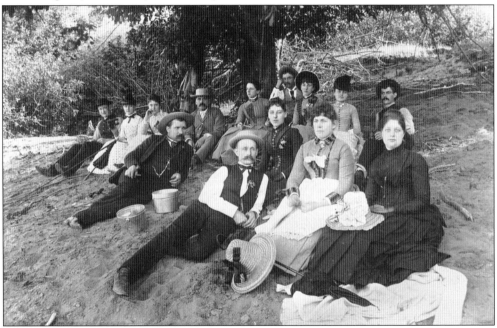

**RIVERSIDE PICNIC.** Picnicking in the late 1800s was a common way to relax and spend time with family and friends. The group in this photograph is enjoying an outing at the Forks, known today as River Forks Park. Located west of Winchester, the Forks is where the North Umpqua River and South Umpqua River converge.

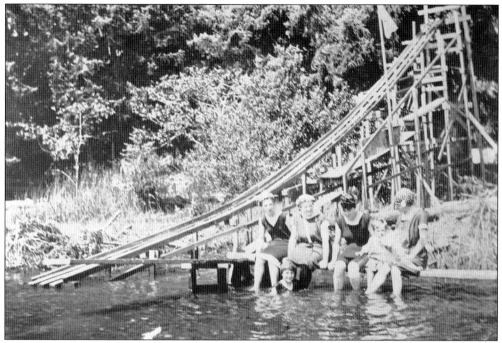

**WATER SPORTS.** Water chutes, such as this one on Butler Creek, were a common sight in the early decades of the 20th century. As well as chutes for hay and logs, these early-day waterslides were built as a fun way to spend hot summer days. Pictured, from left to right, are Mary Lyons, Nora (Melvin) Seymour, Hazel Bernhardt, and Flora Sagaberd. Bernie Sagaberd is sitting on Flora's lap, and Margaret Sagaberd is in the water.

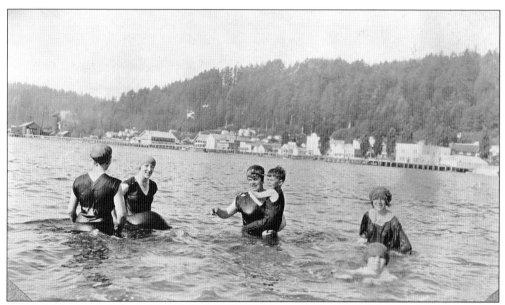

**BATHING BEAUTIES.** These young women and children are enjoying a swim in the surf. Bathing caps made of rubber and fabric protect their hair. In the water, the second woman from the left is Narcissa Jewett. Behind her and her group of friends, the town of Gardiner can be seen.

COASTAL EXCURSION. Seven unidentified people from Oakland have traveled to Winchester Bay on an outing in 1910. They may have arrived in a horse-drawn wagon and have brought a picnic lunch with them to eat on the beach. A friendly fishing and crabbing community, Winchester Bay has long been a favorite vacation area for the people of Douglas County.

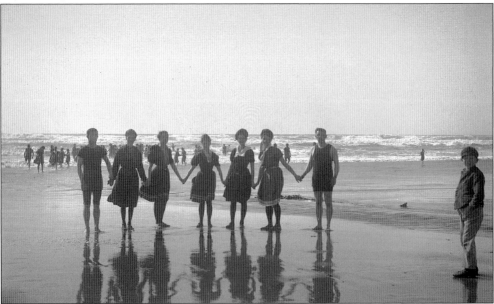

DAY AT THE BEACH. Before swimming pools were common, people cooled off in streams, rivers, and lakes. Even the typically icy Pacific Ocean was a welcome retreat on a clear, sunny day. In this photograph, several people in bathing suits hold hands on the beach, possibly at Winchester Bay. The man on the right is H.O. Lewis, a Roseburg photographer.

**WEDDING GUESTS.** On the back of this c. 1900 photograph is inscribed, "When Fannie Nelson and Capt. Gus Westerdale were married she went with him on the maiden voyage of the four-masted schooner Caroline." These are the wedding guests who accompanied them to the mouth of the river and then returned by tugboat.

**MY FAIR LADIES.** These eight women are promoting the Douglas County Fair, which was to be held at the Douglas County Fairgrounds from August 26 through August 29. Pictured from left to right are (first row) unidentified, Mary Ann Backen, and Mary Schulze; (second row) Diane Myers, Ronda Moe, Virginia Pocock, Kennette Kirk, and Hollene Hansen.

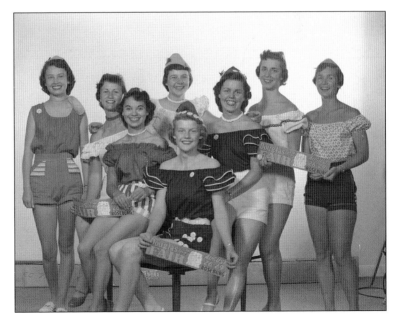

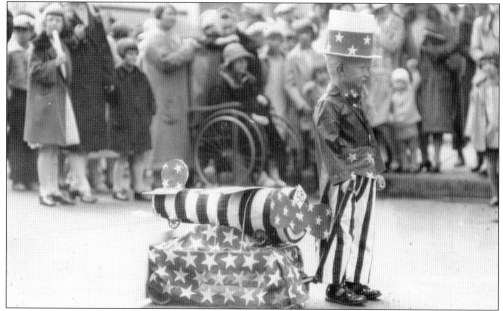

**"Lindberg to Roseburg to Paris."** Gordon Gerretsen, who would one day run Gerretsen Building Supply, is pictured here at age five with his first-prize-winning entry for the wagon division at the Strawberry Carnival around 1930. Gordon told his wife, Pat, many years later that the Uncle Sam beard made of frayed rope was mighty itchy and that his father had to entice him to keep it on and to keep moving down the parade route with pieces of candy.

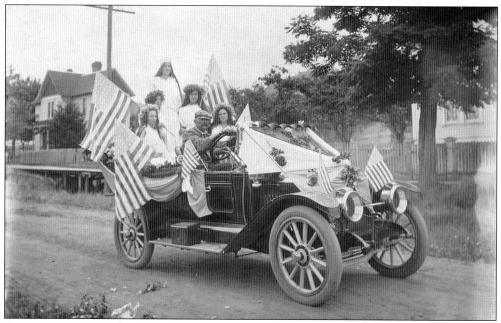

**Fourth of July.** Parade queen Alma Powell and her court are pictured at the Fourth of July event held in Oakland. The flag-and-flower-covered automobile is driven by Ralph Stearns.

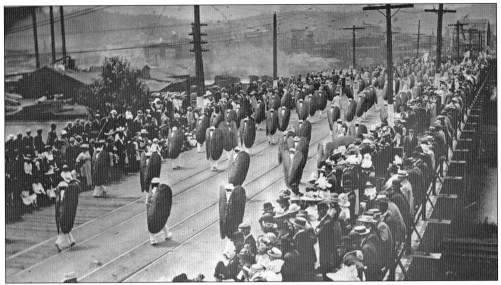

**PARADE DAY.** Parades and other community events have been a significant part of the local culture of Reedsport. A parade in 1912, the year the Reedsport post office was established, even included a troop of "marching mussels," a tribute to one of the many types of seafood harvested in the low tides of the local shorelines.

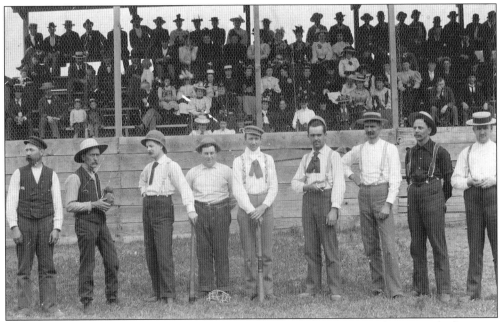

**TAKE ME OUT TO THE BALL GAME.** In the mid-1850s, America's "national pastime" had a major surge of popularity that would continue for many years. This photograph, taken in 1892, shows the Roseburg Single Men's Baseball Team standing in front of a grandstand full of spectators. Players are, from left to right, L.A. Sanctuary, Claude B. Cannon, Silas J. Reizenstein, James A. Perry, George Langenberg, E.L. "Gene" Parrott, and L.A. Walker, who installed the first light plant in Roseburg.

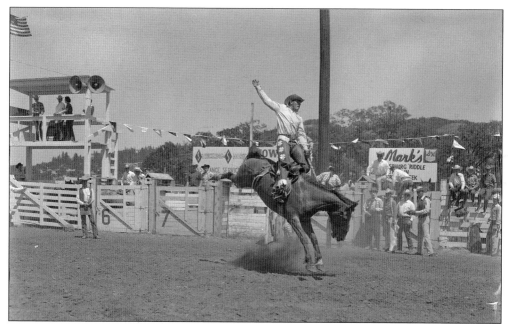

**RODEO DAY.** In these two 1950s images from the Umpqua Valley Roundup held each year at the Douglas County Fairgrounds, unidentified cowboys try to stay on their bucking broncs. The first Douglas County Rodeo was held at the fairgrounds in 1944. In bareback bronco riding, without halter or reins, the horse is completely uncontrolled and will do anything possible to rid itself of the rider. In saddle bronco riding, the rider must hold onto a rope with one hand and continually spur the horse during his 10-second ride.

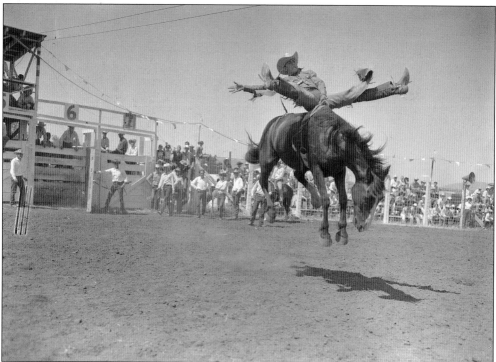

**THEATRICAL TROUPE.** Charades and light entertainment groups were a simple, free way to have fun in the late 19th century. Anyone—whether rich or poor, young or old—could participate in the activities, and even the infirm could be involved from their sickbeds. Seen here around 1890, these unidentified, refined ladies and gentleman have formed their own club specifically to perform charades.

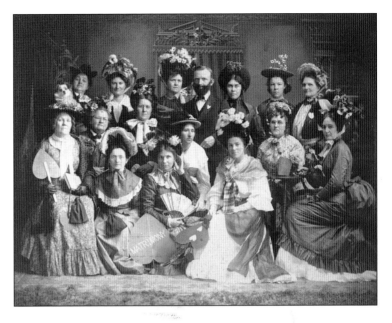

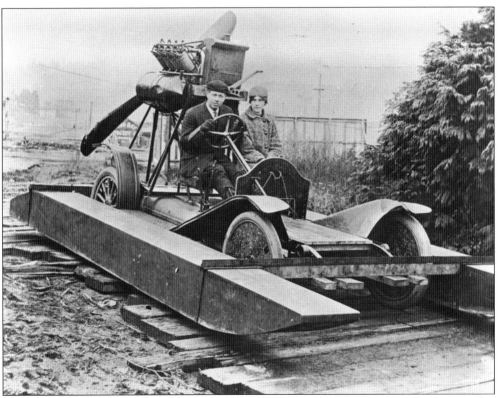

**LAND AND WATER MACHINE.** The early days of transportation are spiced with comic photographs, although obviously not always planned that way. This image is of Mr. and Mrs. Vern Gorst aboard his "land and water machine" in 1914. The vehicle was the running gear of a Hupmobile car fitted with cedar pontoons and powered by airflow from the prop and engine of a Curtiss plane.

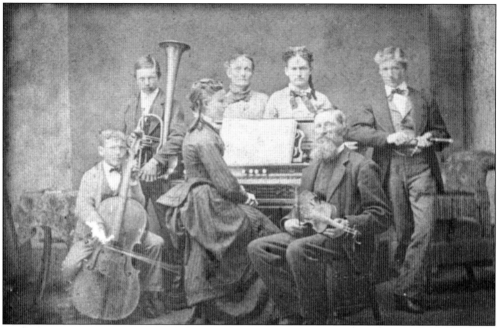

**MUSICAL FAMILY.** The Timothy Lockwood family was well known in Gardiner and as far up the Umpqua River as Scottsburg, where the musicians were invited to play at Christmas, New Year's, and Fourth of July balls held at the Lyons Hotel. There were five family members, and each played a different instrument. Timothy's wife, Elizabeth, ran one of the four hotels in early Gardiner.

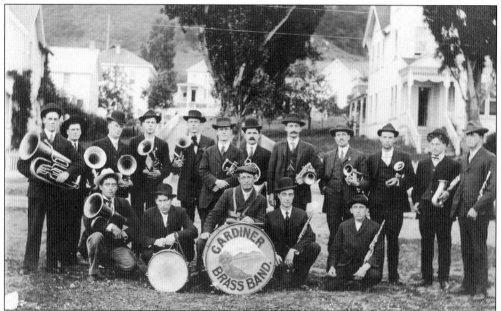

**GARDINER BRASS.** John Phillip Sousa marches were the music of the day, and local men took great pride in their band's ability to entertain. No local celebration worth its salt was complete without a brass band to render patriotic airs at the event. The Gardiner Brass Band's music delighted residents of the lower Umpqua region. Many of the band members were employed by the Gardiner Mill Company, the major business in the bustling seaport.

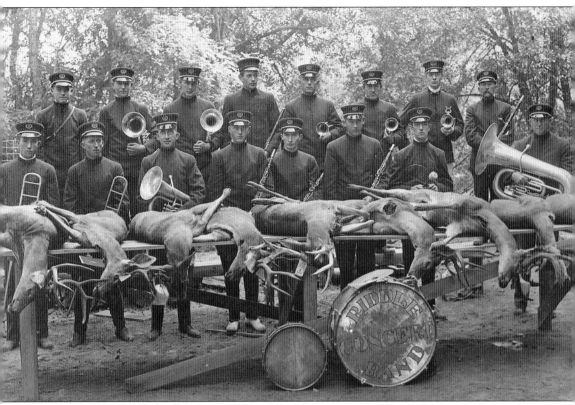

**DINNER AND A CONCERT.** The first Riddle venison barbecue was held on Labor Day in 1913. The event was sponsored by the Riddle Rod & Gun Club. Members of the club combed the hills for deer, and the bucks were held in cold storage, awaiting the day of the great barbecue. The Riddle Band toured the county, playing to advertise the event, which was held in Wollenberg Park, not far upstream from Riddle.

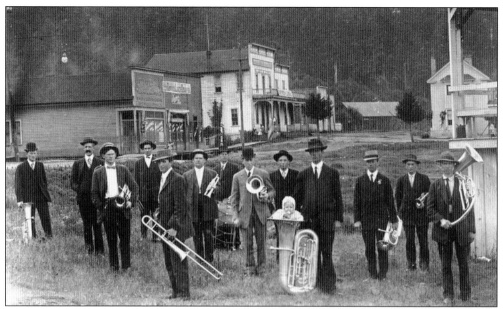

**GLENDALE BAND.** Glendale, southernmost town in the county, came into being in 1881 as Julia when the railroad was building south from Roseburg and was originally named in honor of Julia Hinkle Abraham. The name changed to Glendale in 1883. A helper station on the Oregon & California Railroad, the town has long had an economy based on logging and milling and was a trade center for mines in the area. This 1908 view shows band members holding their brass horns, with an unidentified baby placed in the tuba just for fun.

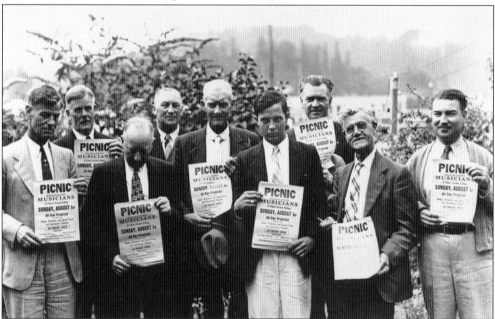

**MUSICAL GET-TOGETHER.** These nine musicians are holding up advertisements for the August 1, 1937, Musicians Picnic in Fisher's Cove at the Kellogg Grange Hall. Included, in no particular order, are W.E. "Billy" Ott, of Ott's Music Store in Roseburg; Charles A. Hartley, of Sutherlin; Lee Kennedy, of Reedsport; and Eldon Fisher, of Kellogg.

*Nine*

# HUNTING AND FISHING

**MOUNTAIN MAN.** Stephen Meek was born on the July 4, 1805, in Virginia. At the age of 20, he entered the services of the Rocky Mountain Fur Company in St. Louis, Missouri. He left his moccasin tracks all over the West, from Yellowstone to the Arkansas River. A free trapper, Meek hired out with the Hudson's Bay Company in 1835 and passed through the Umpqua region for the first time in 1836.

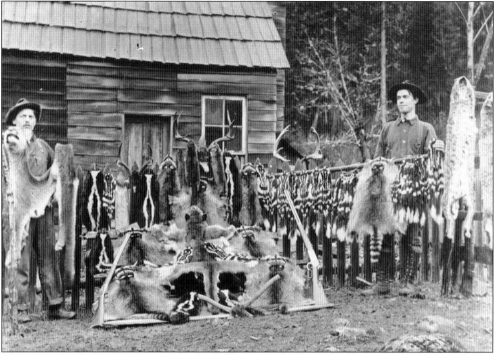

**Fur Trappers.** Fred Asam (left) and another, unidentified trapper show off an assortment of pelts possibly taken from the Cavitt Creek area in the North Umpqua region around 1912.

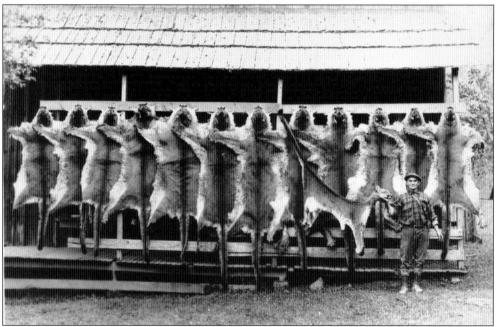

**Bounty Hunt.** Some of the first non-Indian hunters who appeared in the Umpqua region in the 1820s were mountain men. Pictured here about 100 years later is Gard Sawyers, with 13 cougar pelts, probably in the Elkton area. Cougars, also known as pumas or mountain lions, were abundant, and bounty payments fluctuated, reflective of the animal populations at the time.

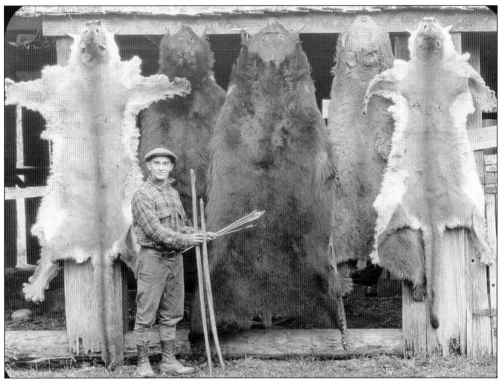

**BOUNTY HUNT II.** Gus Peret of Yoncalla took this 1920s photograph of Gard Sawyers with bows and arrows, two cougar hides, and three bear hides.

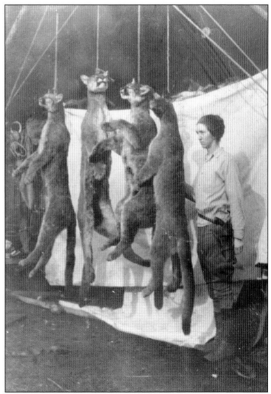

**LADY HUNTER.** Jessie Wright is pictured with a pistol and four cougars killed in the North Umpqua area. In 1915, Jessie and her husband, Perry, homesteaded at Illahee Flats on the North Umpqua. She was a 16-year-old bride at the time. For many years, the Wrights packed in supplies with horses and mules for the Forest Service and early hunters in the area. In her later years, Jessie wrote an entertaining book describing her life on the North Umpqua, called *How High the Bounty*.

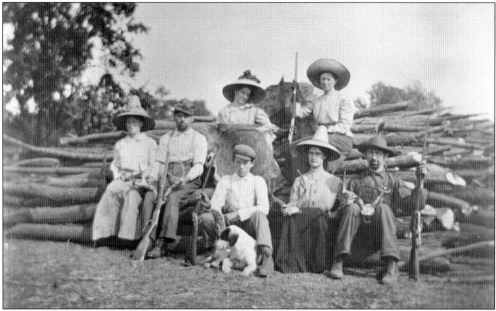

**HUNTING PARTY.** Gathered for the photographer is a hunting party on the Moser ranch, located downriver from Umpqua, Oregon, around 1908. Different styles of hats were worn, and members of the group proudly displayed their firearms, deer antlers, and a hide.

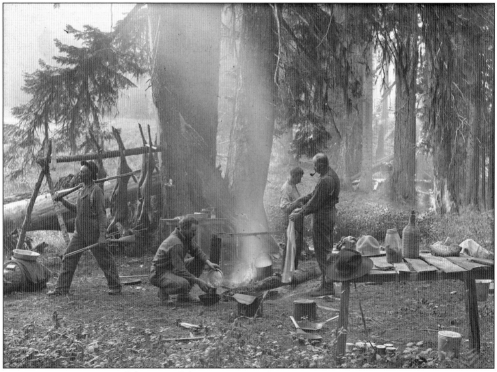

**HUNTING CAMP.** One of the out-of-doors activities for Victorian-era men was hunting. Here are four unidentified men at their hunting camp with an impressive array of camping gear and deer they have hung up on a pole, somewhere in the Umpqua region.

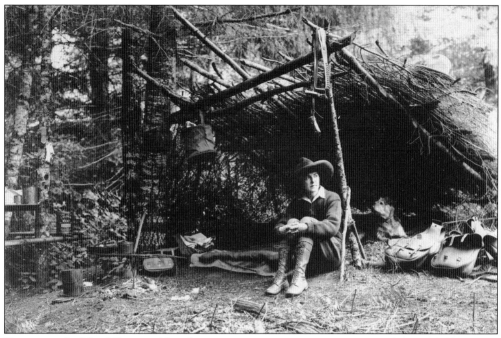

**ROUGHING IT.** Hazel Peret and her dog are pictured in their camp on Yoncalla Mountain in the 1920s. Her husband, Gus Peret, a professional photographer, took the picture. His hat can be seen on top of the lean-to they built using twigs and sticks found nearby.

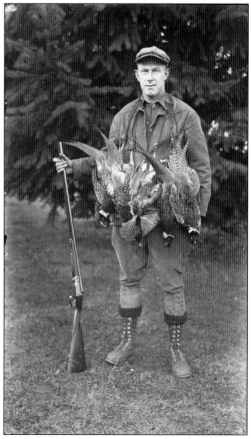

**PHEASANTS.** Gus Peret holds a shotgun and has an impressive display of pheasants tied around his neck in this photographed taken near his home in the Yoncalla area in the 1920s. Peret was a world-famous big-game hunter, photographer, and ammunition representative.

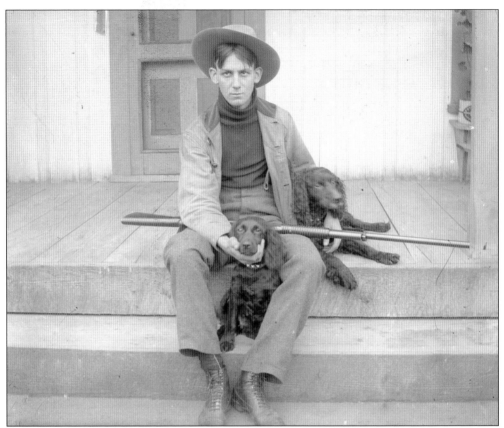

**MAN'S BEST FRIENDS.** Gus Peret of Yoncalla captured this image of an unidentified young man sitting on his porch in the Yoncalla area in about 1918. Wearing hunting attire and with his shotgun in his lap, the man exhibits an obvious fondness for his dogs.

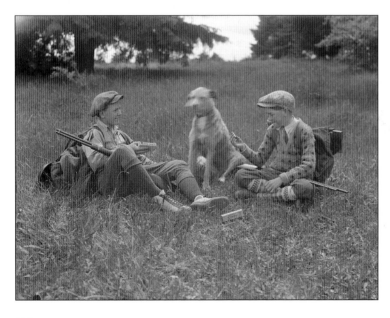

**BAD DOG.** Clyde Kelso (left) and Jack Hartley relax on a grassy hillside in the Yoncalla Valley in the 1920s. Gus Peret posed them inspecting ammunition. Gus's dog was the only one who did not cooperate, with his movement caught on camera due to the slower film speeds in use at the time.

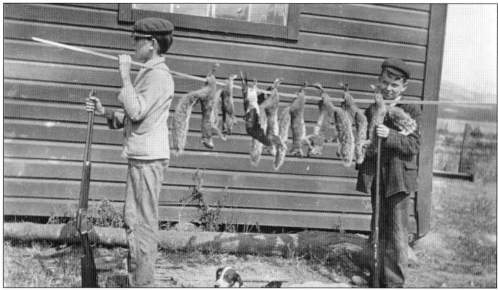

**BIG, BRAVE HUNTERS.** Two unidentified boys from the Dixonville area are shown with their rifles and gray squirrels around 1900. Many youngsters began with hunting squirrels and rabbits and, eventually, advanced to larger game.

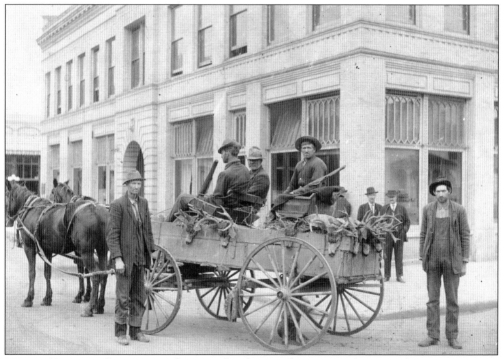

**WAGON FULL.** In this c. 1900 photograph taken at the corner of Cass and Main Streets in Roseburg, the Rose brothers and friends are back in town after a hunting trip. Posing with their wagonload of deer carcasses are, from left to right, Robert Farnsworth, Dick Rose, Frank Rose, Jim Adams, and Ed Rose.

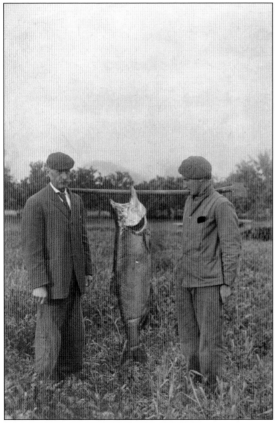

**Tioga Falls.** In 1899, William Harvey (left) and Lilley Weber of Roseburg are pictured standing on the edge of Tioga Falls, now more commonly referred to as the Narrows on the North Umpqua River. During the fall spawning runs, salmon and steelhead ascended the stream to lay eggs in the river gravel below the falls. Fish were frequently so crowded in the pools below the falls that it was a simple task to catch a barrelful.

**Whale-Sized Salmon.** Fishermen in the early 20th century did not have to make up stories about the size of the catch when there was a cameraman handy to snap a shot, as local photographer Abernathy (of Abernathy, Clark & Co.) did in this case around 1900. The unidentified men are using a shovel to support the fish.

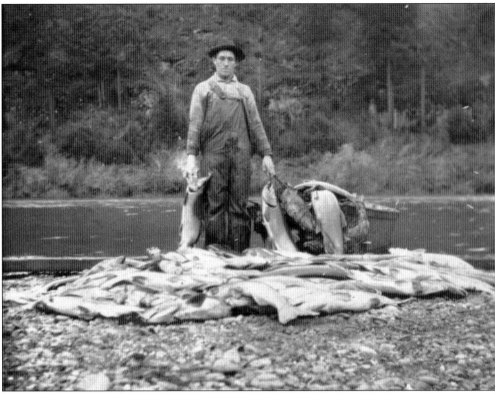

**FULL HAUL.** A 1910 photograph shows James Mortensen and 87 Chinook salmon from one net haul on the Umpqua River. Mortensen lived near Rassmusen Bar.

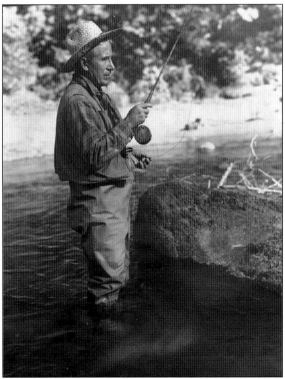

**FISHER OF WORDS.** Zane Grey, one of America's most famous sportsmen and writers, is shown fly-fishing at the Ledges, his favorite pool on the North Umpqua River, located about half a mile below the present-day Steamboat Inn. The North Umpqua River was one of Grey's favorite places to camp and fish. This photograph was taken around 1935, a few years after he decided that the Rogue River had become too crowded to suit him for fishing.

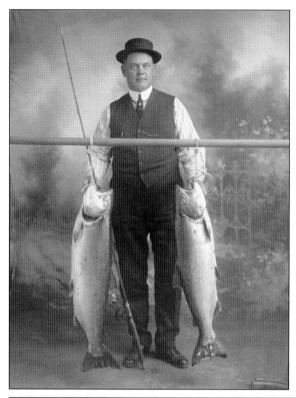

**TROPHY FISH.** A photograph from the Roseburg Commercial Club album show an unidentified man with two Umpqua Chinook salmon caught in 1910. The Chinook is a Pacific Ocean salmon and is the largest species in the salmon family. They are relatively scarce compared to other salmon along the Pacific coast.

**FISHY TALE.** A photograph taken about 1905 shows an unidentified man with a large catch of salmon on the banks of the North Umpqua River. This photograph may be a spoof, as the river appears to be in full spate, making it unlikely that the fish were caught with hook and line.

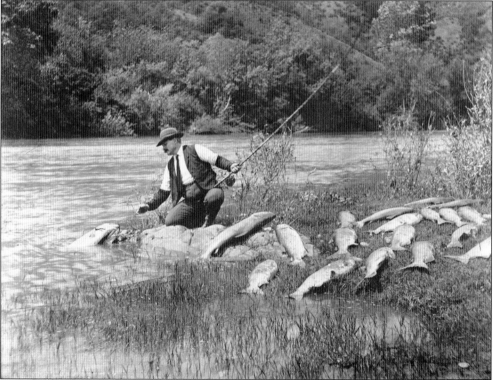

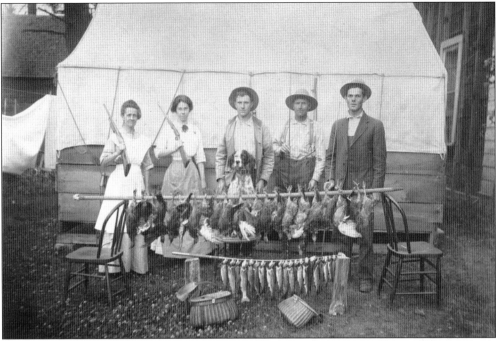

**SPOILS OF THE HUNT.** In this c. 1900 image, a group of men and women shows off the fine birds that have been shot and fish that have been caught. The dog in the center of the photograph looks ready for dinner to get started.

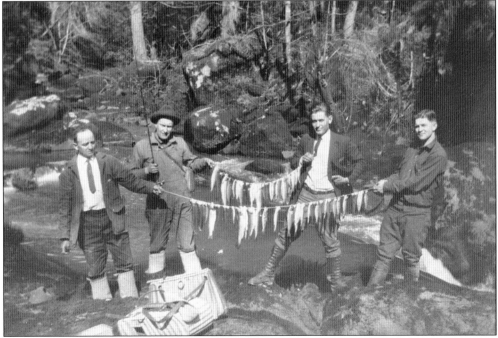

**FISHING TRIP.** This is a pre–World War II photograph of some men fishing on the Coos drainage just below Camas Valley. They are, from left to right, Tom Weatherford, Glen Callen, Irv DeCetee, and Rusty Wangeman.

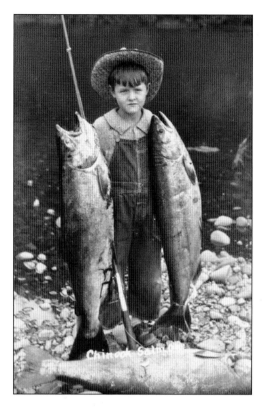

**BIG ANGLER.** In this early-20th-century photograph of an unidentified young fisherman with his Chinook salmon catch, the fish appear to weigh almost as much as he does. It is probably safe to say that someone a bit larger caught these fish.

**BIG ENOUGH TO EAT.** Opal Whiteley and an unidentified boy pose with a large sturgeon caught by Hugh Pearson on April 3, 1916. These ancient bottom feeders were caught throughout history on the peaceful Umpqua River, and the river guides today boast about some of the world's best sturgeon fishing on the Umpqua.

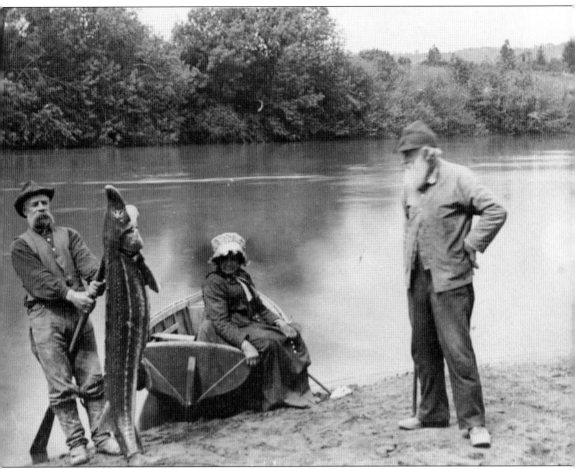

**ROSEBURG STURGEON.** Frank Harvey (with fish), son of Arvilla Harvey (in boat) and William Harvey (right), uses a boat oar to prop up a sturgeon caught on the South Umpqua River right off their farm around 1900. The Harvey place was located about where the Veterans Administration and Stewart Park are today. This view is looking south toward Harvard Avenue.

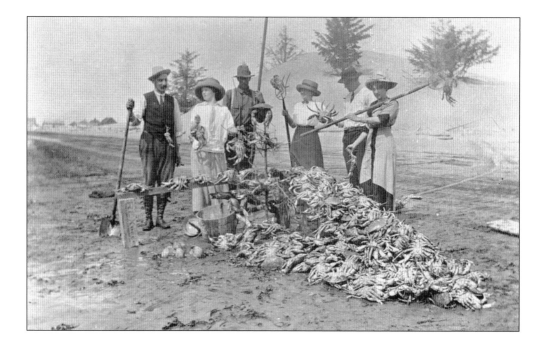

CRABBING. Winchester Bay is renowned as an excellent crabbing site, the most harvested varieties being Dungeness and Red Rock crabs. Since the late 19th century, Dungeness crabs have been harvested along the Pacific coast for market. Red Rock crabs, although too small to be sold commercially today, have always been a favorite catch at the Oregon seashore, as seen in these photographs taken in August 1913.

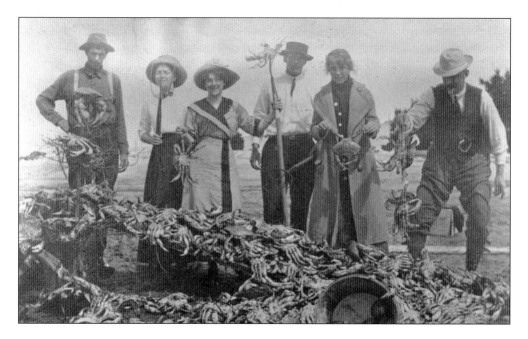

# About the
# Organization

**Douglas County Museum.** The Douglas County Museum and its sister site, the Umpqua River Lighthouse Museum, share artifacts, historic photographs, and stories that bring history to life for thousands of visitors each year. Find out more at www.douglasmuseum.com.

# DISCOVER THOUSANDS OF LOCAL HISTORY BOOKS
## FEATURING MILLIONS OF VINTAGE IMAGES

Arcadia Publishing, the leading local history publisher in the United States, is committed to making history accessible and meaningful through publishing books that celebrate and preserve the heritage of America's people and places.

Find more books like this at
**www.arcadiapublishing.com**

Search for your hometown history, your old stomping grounds, and even your favorite sports team.

Consistent with our mission to preserve history on a local level, this book was printed in South Carolina on American-made paper and manufactured entirely in the United States. Products carrying the accredited Forest Stewardship Council (FSC) label are printed on 100 percent FSC-certified paper.

MADE IN THE USA